AUG -- 2008

W9-DFE-806

DISCARD

International Standard Book Numbers:
ISBN-10: 1-56579-553-9
ISBN-13: 978-1-56579-553-2

Text: © 2007 Jonathan Genzen. All rights reserved.
Photography and Illustrations: All rights reserved. As credited on pp. 92-93.

Editor: Jennifer Jahner
Designer: Kimberlee Lynch
Production Manager: Craig Keyzer

Published by:
Westcliffe Publishers, Inc.
P.O. Box 1261
Englewood, CO 80150

Printed in China by: C&C Offset Printing Co., Ltd.

Library of Congress Cataloging-in-Publication Data:
Genzen, Jonathan.
 The Chicago River : a history in photographs / Jonathan Genzen.
 p. cm.
 Includes bibliographical references and index.
 ISBN-13: 978-1-56579-553-2
 ISBN-10: 1-56579-553-9
 1. Chicago River (Ill.)--History. 2. Chicago River
(Ill.)--History--Pictorial works. 3. Chicago (Ill.)--History. 4.
Chicago (Ill.)--History--Pictorial works. I. Title.
 F547.C45G46 2006
 977.3'1100222--dc22 2006022119

For more information about other fine books and calendars from Westcliffe Publishers, please contact your local bookstore, call us at 1-800-523-3692, or visit us on the Web at **westcliffepublishers.com**.

The author and publisher of this book have made every effort to ensure the accuracy and currency of its information. Nevertheless, books can require revisions. Please feel free to let us know if you find information in this book that needs to be updated, and we will be glad to correct it for the next printing. Your comments and suggestions are always welcome.

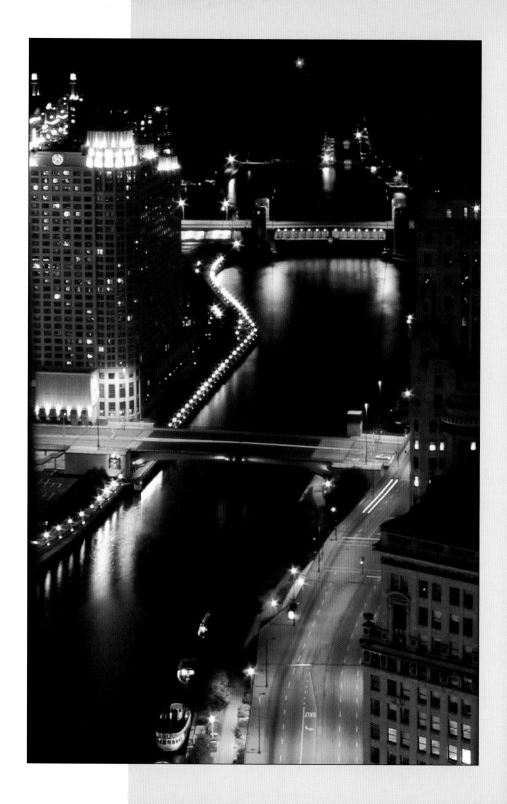

To my family.

You could pick out

white with blue trim

and take it out past

The Wrigley Building.

You could float away

from suburbs and fences,

get away from all

those trying to get

away from it all.

Glide under the highway,

forget all that desk space

you share at noon.

—Dawn Tefft

"Canoeing the Chicago River"

3

Introduction

The story of the Chicago River is in many ways the story of Chicago itself—a narrative of a city, its people, and the struggle between urban development and the natural landscape. From its origin as a small natural river to its dramatic transformation into a modern navigational connection between the Great Lakes, Illinois, and Mississippi River systems, the Chicago River has been shaped by human ingenuity, economic need, and even disaster. Astonishing tales of exploration and settlement, pollution and recovery, highlight the vital link between the welfare of Chicago and the condition of the Chicago River—a relationship that continues to evolve with the growing needs of the expanding metropolis.

Fortunately, this remarkable history parallels the development of modern publishing and photography. Historical societies, libraries, civic organizations, photographers, and private collectors possess thousands of images portraying the evolution of this enduring river. The pictures in this book were selected as unique illustrations of the Chicago River's history—many have never been published before. For centuries, the Chicago River has captured the imaginations of explorers, artists, engineers, photographers, and recreationists, a number of whom have had a hand in the images presented here. The drawings and maps that mark the river's early navigation give way to the black-and-white photographs of the 19th and early 20th centuries. These, in turn, guide us toward a modern perspective on the waterway through the color photographs that document the river today. All of these are part of the story of the Chicago River…a story that is retold and reinvented with each new generation.

—Jonathan Genzen

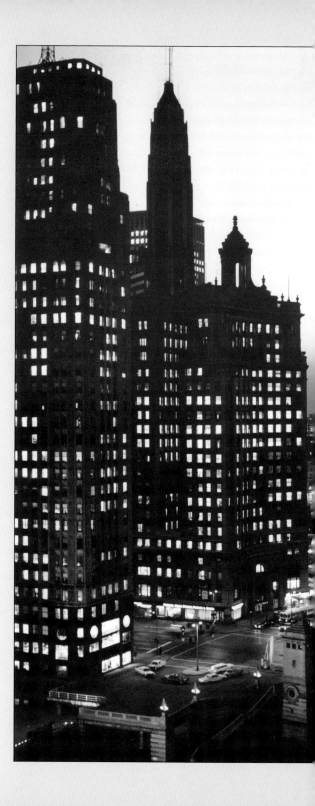

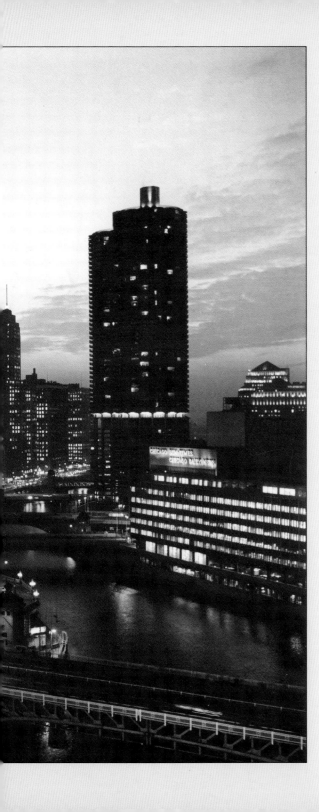

Contents

Beginnings:
The Bedrock of Chicago

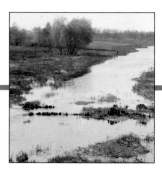

The Natural Landscape

"The river is everywhere at once," writes Hermann Hesse in *Siddhartha*, "at the source and at the mouth, at the waterfall, at the ferry, at the rapids, in the sea, in the mountains, everywhere at once." The Chicago River, too, is a river that is "everywhere"—its shifting currents have integrally shaped every aspect of the city that has grown alongside it. Why was Chicago founded along the banks of this subtle river? What brought explorers and settlers to the southwest corner of Lake Michigan? More importantly, why did so many of them stay?

The answer is simple: the Chicago River, while modest in the scale of U.S. waterways, provides an invaluable link between two separate but massive watersheds. But before we can understand how this geographic coincidence inspired the growth of one of America's greatest cities, it is important to understand the origin of the landscape…a story of water, ice, and bedrock.

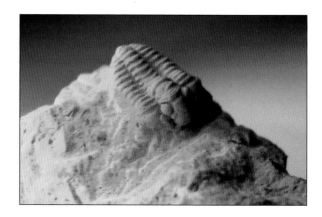

▲ A fossilized trilobite, likely a *Gravicalymene* from the Paleozoic era during the Silurian period. It is 417–443 million years old and comes from a northeastern Illinois excavation.

A state map of Illinois showing geologic deposits over the last two million years (the Quaternary period). The dark green shading indicates the end moraines left throughout northeastern Illinois by massive Ice Age glaciers of the late Wisconsin episode, ending approximately 12,000 years ago. The glacial moraines help determine the flow of rain water into northeastern Illinois' river and lakes. Geology throughout the state was also heavily influenced by the earlier Illinois episode of glaciers ending 125,000 years ago (see pink shading). Numbers and red lines throughout the entire map indicate the depth of silt, or sedimentary material that was deposited throughout the Illinois landscape during the Quaternary period.

Four hundred million years ago, a vast ocean brimming with life submerged the entire region of present-day Chicago. Over time, the continents shifted and the water receded, exposing the seafloor. Sediment from this ancient ocean forms the bedrock of limestone and dolomite upon which Chicago now stands. Exposed bedrock in local cliffs, quarries, and construction sites provides evidence of this distant era in fossilized remains.

During the more recent ice ages, massive glaciers from the north plowed through the rugged landscape of the Chicago region. These glaciers radically modified the terrain by flattening everything along their path and covering the land in thousands of feet of ice. The latest of these glaciers, the Wisconsin, receded more than 12,000 years ago, leaving deposits of soil and rock, or drift, that dramatically shaped the present landscape. Large ridges in the earth called moraines formed as the Wisconsin glacier advanced and receded.

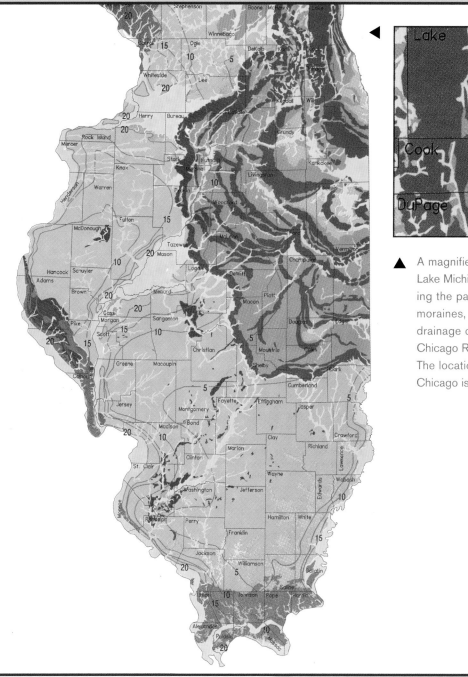

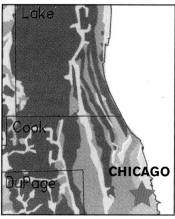

A magnified view along the Lake Michigan shoreline showing the parallel Lake Border moraines, which guide the drainage of water into the Chicago River's North Branch. The location of present day Chicago is marked by a star.

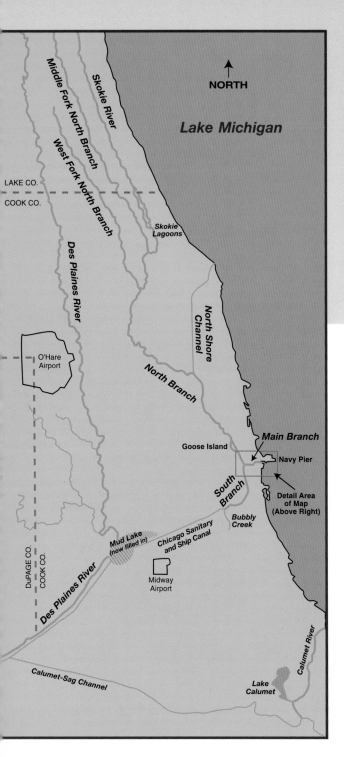

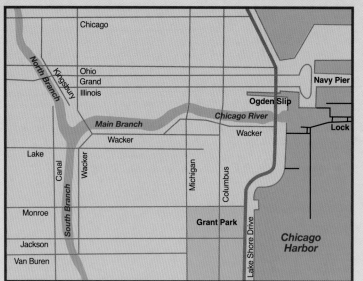

◀

Detail area showing the Main Branch of the river in downtown Chicago.

▶

The North Branch of the Chicago River, circa 1904. The landscape resembles the river's natural character before the time of European exploration and American settlement.

Glacial activity also created a subcontinental divide, which continues to influence the topography of the Chicago region. While certainly not as noticeable as the massive Continental Divide of the Rocky Mountains, this subtle, imperceptible feature of the landscape proved tremendously important for the story of the Chicago River. An extra few feet of elevation just west of present-day Chicago determined whether rainwater drained toward the Chicago River, Lake Michigan, and the Atlantic Ocean to the east or into the Des Plaines, Illinois, and ultimately Mississippi Rivers to the west.

Originally called *chicagoua*, an American Indian word for a plant found along the river's edge, the Chicago River once quietly passed through forests and grasslands along one side of the subcontinental divide. With currents heavily influenced by seasonal variation in rain and snow, the Chicago River frequently overflowed after storms. During periods of drought, however, the river was slow, hardly a creek, although still a wellspring of life. This early Chicago River extended over 40 miles with a 100-foot drop in elevation. Three major tributaries of the North Branch merged and flowed toward the location of present-day downtown Chicago. At the juncture of the North and South Branches, the Main Branch extended one mile toward the river's mouth at Lake Michigan. From its origin near historic Mud Lake, the South Branch of the Chicago River extended approximately four miles from the southwest before merging into the Main Branch and emptying into Lake Michigan. The modern Chicago River largely follows this same course, although massive public works projects have actually reversed the direction of the South and Main Branches.

◀

Map of the Chicago River. Note the three natural tributaries of the North Branch (West Fork, Middle Fork, and Skokie River). The man-made North Shore Channel also feeds into the North Branch. The Main Branch is found at the juncture of the North and South Branches. Water in the Chicago River system now flows toward the South Branch, where it empties into the Chicago Sanitary and Ship Canal.

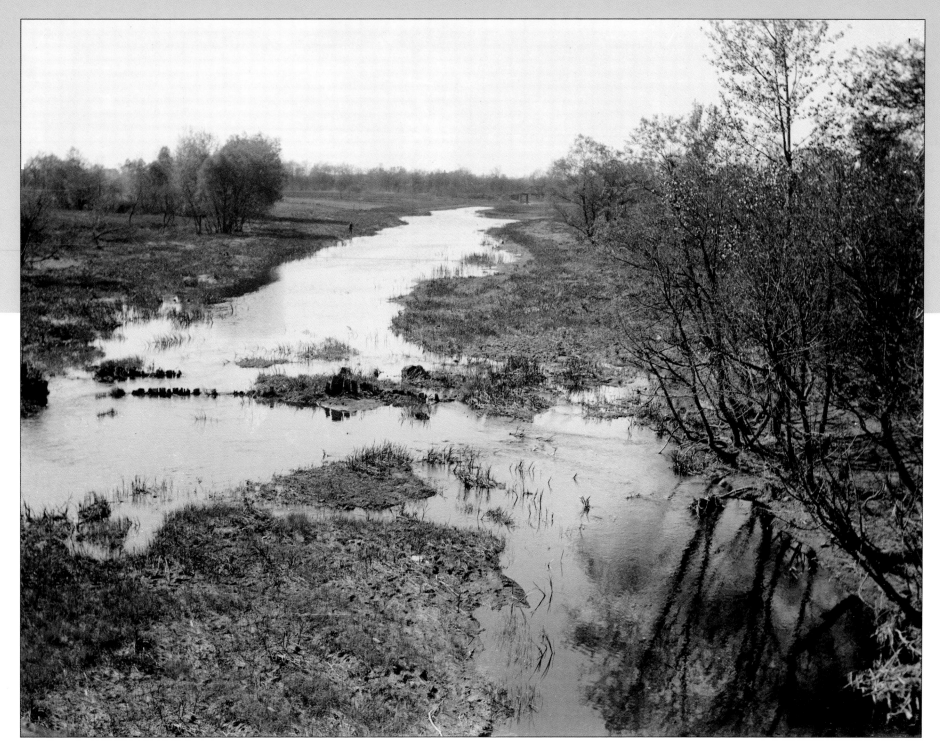

A Sluggish River in the Great Frontier (1600–1800)

Native Inhabitants of the Chicago Region

When European explorers traversed the Chicago region in the mid-1600s, the indigenous American Indian populations had already been dramatically influenced by the growing pressure from the European settlements to the east. Explorers such as Marquette, Joliet, and La Salle encountered numerous tribes on their expeditions, including the related Miami and Illinois Indians. Early interaction between the European explorers and these tribes was remarkably peaceful.

The Miami and Illinois populations, however, soon decreased in number around the Chicago region, due in part to the threat from Iroquois invasion. By the late 1700s, the Potawatomi tribes predominated in the area along the Chicago River. They were descendents of an ancestral tribe related to the Chippewa and Ottawa and originally settled along the western shore of Michigan until Iroquois attacks forced them to flee toward current

Wisconsin. However, their territories rapidly extended southward toward the Chicago River. The Potawatomi relied heavily on their proximity to the river for food as well as transportation. Tribal settlements populated the edges of this quiet waterway, and the critical importance of the river for their livelihood cannot be overemphasized.

▶

George Winter's *Scene on the Wabash* captures Potawatomi life along the water—in this case, along Indiana's nearby Wabash River. Oil on canvas; 29 by 36 inches (photo courtesy of the Gerald Peters Gallery)

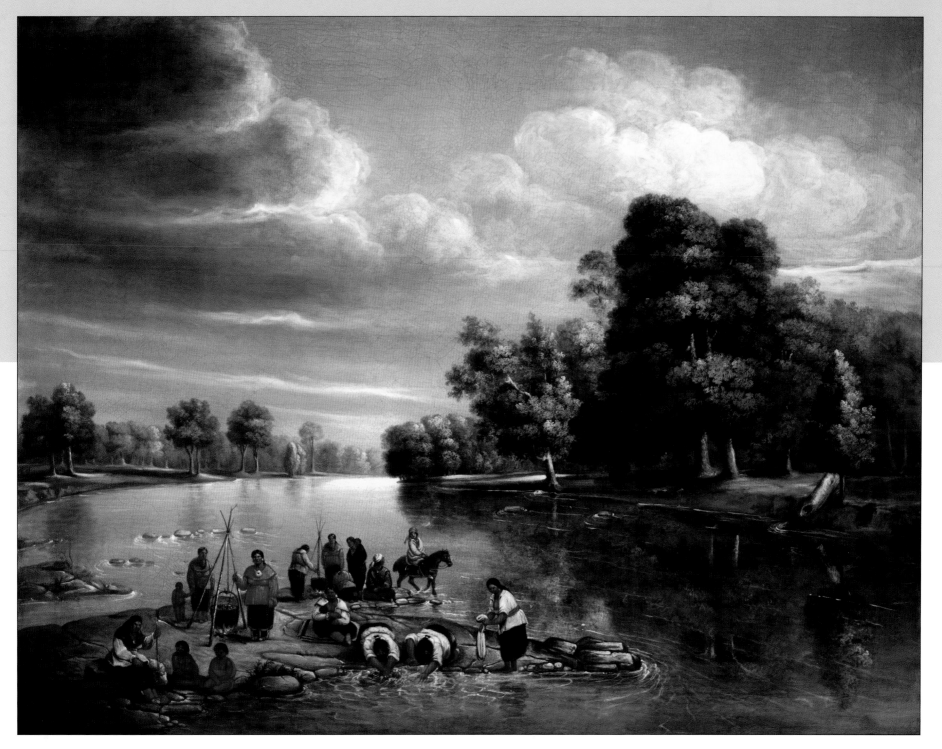

Bronze plaque of Louis Joliet
by Edward Kemeys, 1894

Father Jacques Marquette in
a painting by R. Roos, 1669

The Chicago Portage

Many early expeditions across the Great Lakes and Mississippi watersheds were motivated by economic interests, including a burgeoning fur trade, and a desire to find transportation routes across the New World. Other explorers were interested in the religious conversion of indigenous inhabitants. All, though, shared in the spirit of adventurism and expansionism that was the hallmark of the era. Of the many explorers who passed through the region, the names Joliet, Marquette, and La Salle have left an enduring mark on Chicago. Passage through the Chicago River was critical to the success of each of their journeys.

In 1673, a cartographer from New France and a French-born Jesuit missionary joined forces to explore the "Great River"—the Mississippi waterway rumored to exist in the West. In doing so, they became the first non-Native inhabitants to pass through the current boundaries of Chicago. More importantly, they were the first explorers to specifically advocate using the Chicago River as a

connection between the Great Lakes and the Illinois and Mississippi River systems, a navigation route that was taken by countless traders in the centuries to follow.

Louis Joliet, or Jolliet, was born in New France to immigrant parents. Initially trained as a Jesuit priest, Joliet was a talented musician who developed equally impressive business skills as an industrious fur trader. Familiar with the known water routes of New France, Joliet gained a practical education in both hydrology and mapmaking. Together, these skills proved critical to the success of his amazing journey. Father Jacques Marquette was an educated, French-born Jesuit missionary. Marquette also longed to explore the new frontier, though his motivation was primarily a religious one—to share the teachings of Christianity with the Native inhabitants. This ambition motivated his journey to New France and his subsequent transfer to the faraway mission at St. Ignace in the Straits of Mackinac. With the approval of the Canadian governor

and his Jesuit superior, Marquette was provided with instructions to explore the Great River and determine if it emptied into a "Southern Sea."

Together with a small crew of companions, Joliet and Marquette loaded their canoes with supplies and traveled over 1,000 miles from the northern regions of Lake Michigan down the Fox and Wisconsin Rivers and to the confluence of the Mississippi River. They then paddled southward down the Mississippi River all the way to what is now Arkansas. At this point, they compiled sufficient evidence from coordinates, maps, and reports from local

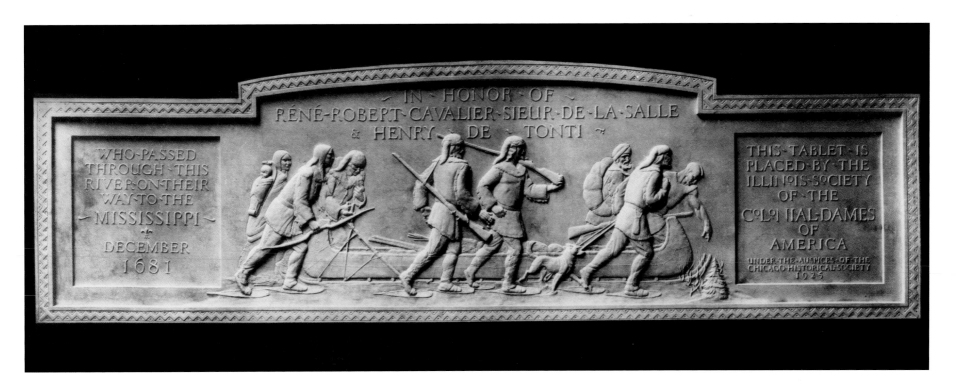

▲ Plaque on the Michigan Avenue Bridge, placed in 1925 to commemorate the journeys of La Salle and Tonti and their profound impact on the Chicago portage.

tribes to conclude that the Mississippi River indeed emptied into the Gulf of Mexico. Continuing their journey southward risked attack from hostile tribes and capture by the Spaniards. Joliet and Marquette therefore began their return trip northward, an almost unthinkable paddle upstream. A shortcut was desperately needed.

On advice provided earlier in their journey, Joliet and Marquette followed a different course on this return trip. They chose an alternative route up the Illinois and Des Plaines Rivers toward Lake Michigan. On this historic detour, they became the first non-Native inhabitants to traverse the Chicago portage—a short (albeit miserable) trek through the swampland of Mud Lake from the Des Plaines River to the South Branch of the Chicago River, crossing the subcontinental divide. Unbeknownst to Marquette and Joliet, this valuable water route between the Great Lakes, Illinois, and Mississippi river systems would ultimately inspire a settlement at Chicago and the establishment of one of America's largest cities. Joliet envisioned the possible construction of a permanent canal across this swampland. While it is likely that excessive rain that year made the portage unusually short (and the idea of a canal particularly optimistic), a canal eventually *would* be built, over 170 years later.

In a catastrophic accident, Joliet lost all of the maps and travel diaries from this incredible journey when his canoe capsized just a few miles from his home in Montreal. He escaped with his life, although three of his companions perished in the tragedy. Much of what we now know about this journey comes from the writings of Marquette and the verbal reports of Joliet after his return. Father Marquette returned to the Chicago portage in 1674 to establish a religious mission with the Illinois Indians. Ill health brought his mission to an early conclusion, and Marquette died on the return trip to St. Ignace in 1675.

René-Robert Cavelier Sieur de La Salle also passed through the Chicago portage in 1681. La Salle and his associate, Henri de Tonti, had a profound impact on the region, establishing Fort St. Louis on the Illinois River and Fort Miami on the St. Joseph River. A proponent of an alternative St. Joseph River connection to the Illinois River system, La Salle summarily dismissed Joliet's notion that a canal could traverse the Chicago portage. La Salle's famed explorations of the Mississippi and Illinois Rivers, however, helped spread information about the region and its inhabitants, inspiring others to travel through the Chicago River. The mouth of the Chicago River, however, remained free from permanent European settlement for another 100 years.

La Salle's fate would be decided much sooner. On a failed attempt to identify the mouth of the Mississippi River from the Gulf of Mexico, a navigational miscalculation landed La Salle and his crew on the shores of what is now Texas. Starvation, disease, and disagreement culminated in his murder at the hands of an angry companion in 1687.

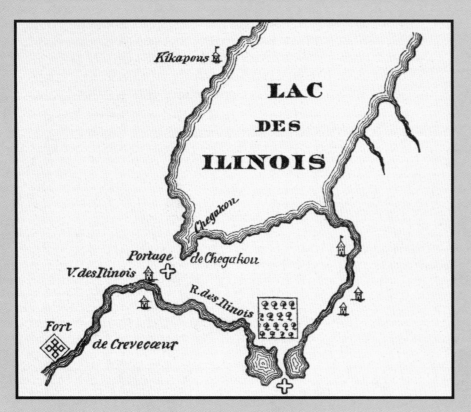

This map of Lake Michigan (*Lac des Ilinois* in French), drawn by Baron de La Hontan in 1703, makes note of the Chicago portage.

Chicago in 1779. The aquatint engraving by Raoul Varin (1865–1943) depicts the Du Sable cabin near the mouth of the Chicago River. While no accurate historical drawings of Du Sable exist, the portrayal at bottom right is commonly used to describe his appearance.

Du Sable and Early Settlement

Many other travelers crossed the Chicago portage over the next 100 years, although few stayed for any prolonged period of time. Around 1779, however, Jean Baptiste Point du Sable arrived at the Chicago River by canoe and built a cabin along the northern bank of the river near its mouth at Lake Michigan. Little is actually known about Du Sable's early life, although it is commonly believed that he was of Haitian or African descent. Du Sable lived along the Chicago River for 15 to 20 years. He married a Potawatomi woman named Catherine, the daughter of a prominent chief. At the time, the Main Branch of the Chicago River drained a

marshy lowland of small streams, an unimaginable contrast to the intense urbanization of today's downtown waterway. Although Du Sable left the area long before the town of Chicago was established, he is a figure of mythic proportions in Chicago's history. His life in Chicago is now honored by the naming of DuSable Harbor, the DuSable Museum, and DuSable Park. Du Sable moved from Chicago in approximately 1800, after the death of his wife and son, and resettled in what is now Missouri, where he died in 1818. His Chicago property was sold to Jean La Lime, who quickly passed it along to the industrious John Kinzie.

John Kinzie was born in Quebec and trained as a silversmith. He established himself as a fur trader before moving to Chicago in 1804. Often referred to as "the father of Chicago," Kinzie expanded Du Sable's small cabin into a much larger house, where he lived with his second wife Eleanor until 1828. He quickly became a prominent trader with the officers and soldiers of the recently constructed Fort Dearborn, and he wisely befriended many of the local Indian tribesmen. Kinzie briefly fled Chicago in 1812 after the suspicious murder of Jean La Lime, but he soon returned to his home on the Chicago River after a fortuitous acquittal.

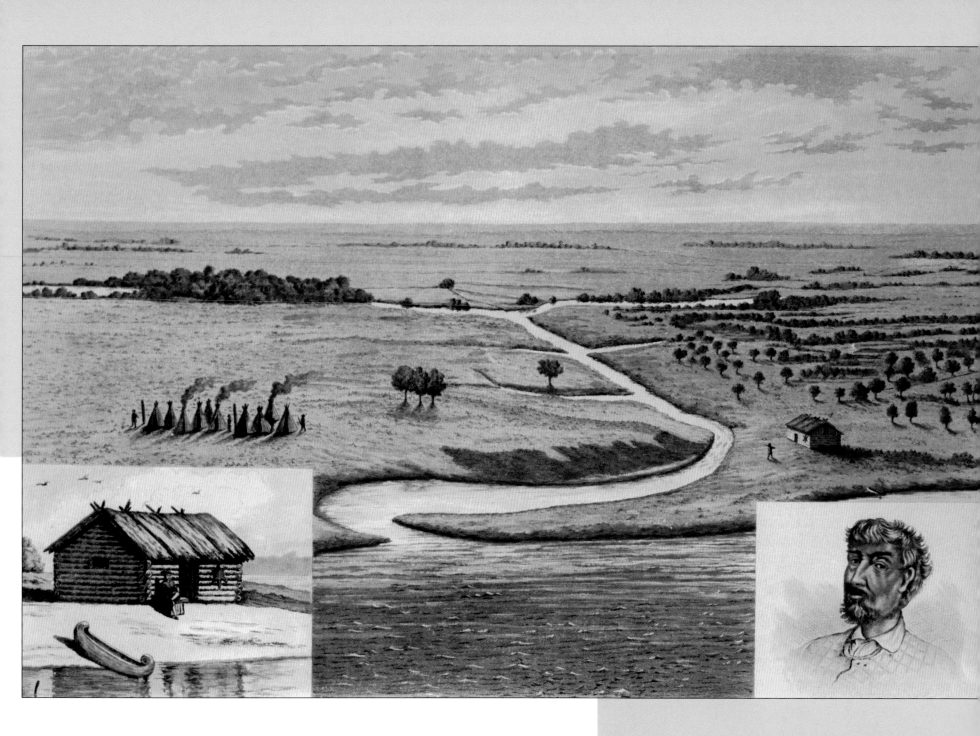

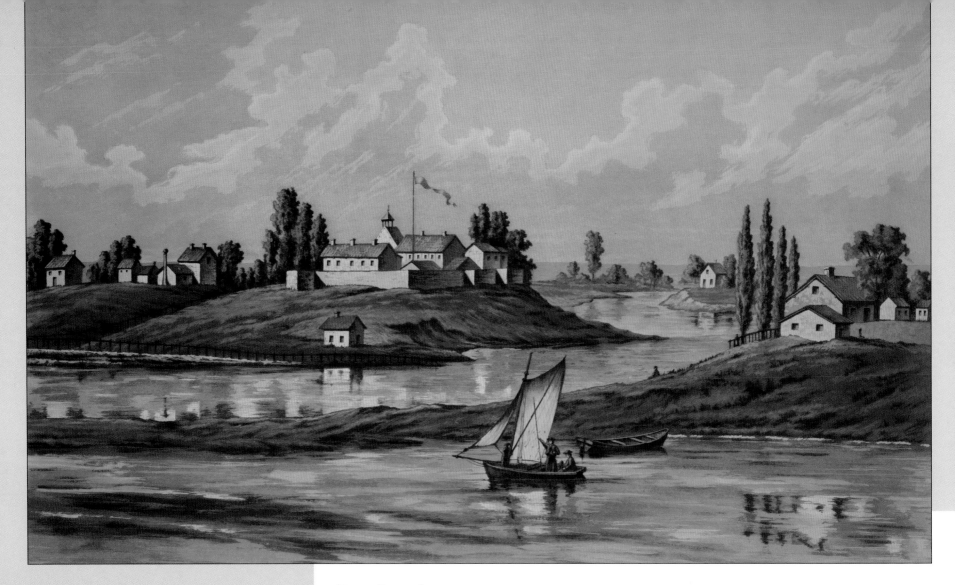

▲ A depiction of the expanding Chicago settlement in 1831, including Fort Dearborn along the southern bank of the Chicago River's Main Branch. Du Sable's former cabin on the northern bank (at right) has been expanded by John Kinzie into a much larger house.

Fort Dearborn

Recognizing the strategic importance of the Chicago portage, the U.S. government ordered a fort constructed at the mouth of the Chicago River in 1803. Indian tribes previously ceded this land to the United States after the Treaty of Greenville in 1795. The first commander of the newly constructed Fort Dearborn was John Whistler, the grandfather of James McNeill Whistler, renowned painter of *Whistler's Mother*. Captain Nathan Heald took over command in 1810. The settlement of traders and pioneers in Chicago quickly expanded due to the security afforded by Fort Dearborn's proximity.

Increasingly negative reaction among Indian tribes toward the growing settler encroachment, however, led to threats of attack against Fort Dearborn. These sentiments were largely supported by the British, who hoped to gain control over the territories. The War of 1812, as well as

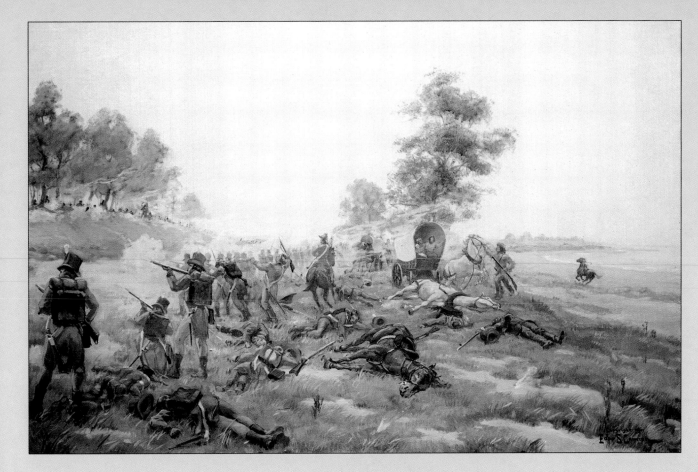

The Fort Dearborn Massacre,
as depicted in a painting by
Edgar Spiers Cameron, 1911

the belief that Indian attack was inevitable, prompted General William Hull to issue an order for the evacuation of Fort Dearborn in the summer of 1812. Soldiers began to destroy excess supplies and weapons on August 13, and any remaining alcohol was infamously poured into the Chicago River before their departure. John Kinzie insisted on traveling with the soldiers by foot, as he hoped that his friendship with local tribesmen might bring fellow settlers and soldiers additional protection. Together they began to evacuate on August 15, 1812, escorted by a large group of mostly Potawatomi Indians. Shortly after leaving the security of Fort Dearborn, however, the Potawatomi left the settlers and disappeared behind nearby dunes—the

settlers were soon ambushed. Well over 60 people were killed in the assault, and Fort Dearborn was ransacked and burned to the ground. Survivors were taken to Indian encampments until a negotiation for their freedom could be reached.

Fort Dearborn was rebuilt in 1816, although it closed numerous times over the subsequent 20 years as Chicago expanded and the threat from tribal and British invasion diminished. By the late 1850s, most of Fort Dearborn had been demolished. The little that remained was destroyed by the Great Chicago Fire of 1871. Sidewalk markers near the Michigan Avenue Bridge now designate the former location of Fort Dearborn along the Chicago River.

For American Indian tribes, however, the future in Chicago was bleak. By the late 1830s, over 30 treaties ceded land to the United States, including the 1833 Treaty of Chicago, which surrendered millions of acres of land to the U.S. government in exchange for payments and territories west of the Mississippi River. Remarkable gatherings of Indians in 1833 and 1835 occurred in Chicago for these negotiations, events that highlighted the profound cultural contrast between a developing city and the Indian tribes who previously made the region home. By the 1840s, essentially all of the remaining tribes had left the Chicago area.

Chicago Rises Along the Riverbanks (1800–1900)

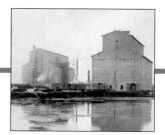

A City Grows Along the River

Chicago resumed its growth with the resolution of the War of 1812, the reconstruction of Fort Dearborn, and the impending departure of the Indian inhabitants. Establishments such as Wolf Point Tavern and Miller's Tavern were constructed along the Chicago River in the early 1820s. These were built near "Wolf's Point," a prominent location at the junction of the North and South Branches. The popular Sauganash Tavern opened shortly thereafter on the opposite side of the Chicago River. The city rapidly expanded from a population of less than 100 in 1829 to a few thousand by the late 1830s. In 1837, Chicago was incorporated as a city under its first mayor William B. Ogden. By 1845, Chicago had the dubious distinction of boasting 12,000 inhabitants but four times that number of livestock!

Access to the Chicago River was obstructed by a sandbar, prohibiting large vessels from entering the waterway from Lake Michigan. Channels through the sandbar were

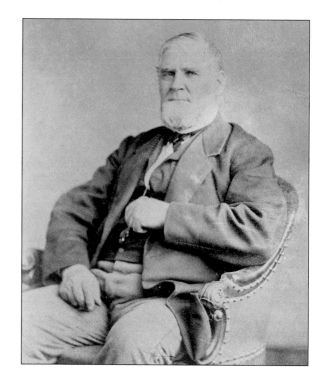

▲ William B. Ogden, the first mayor of Chicago

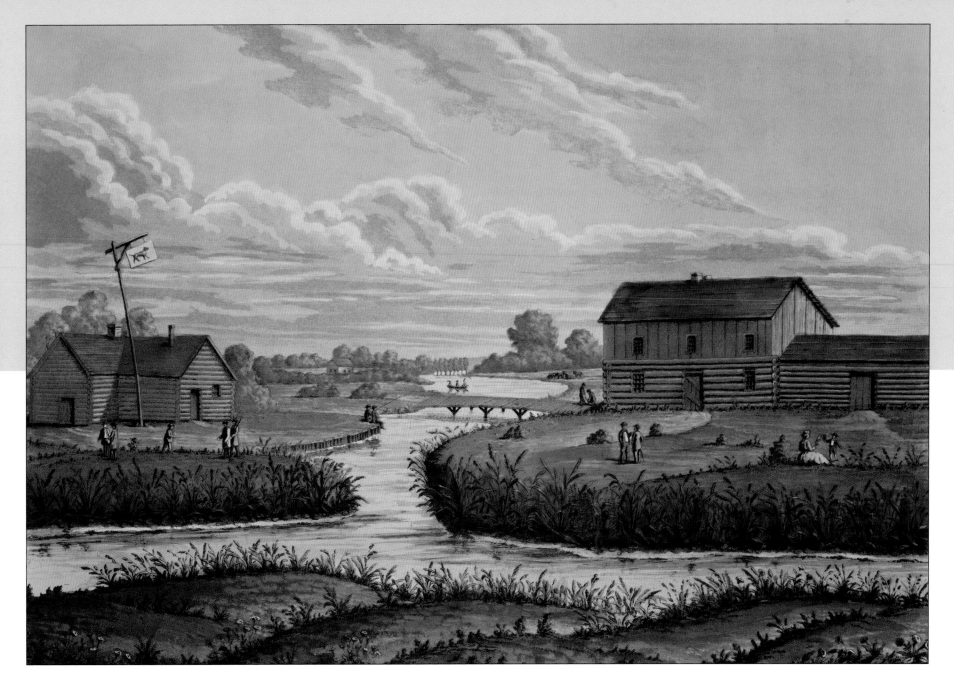

▲ A depiction of Chicago in 1833. Numerous businesses and taverns, including Wolf's Tavern (left) and Miller's Tavern (right), were
located near the point where the North Branch joined with the South Branch to form the Chicago River's Main Branch.

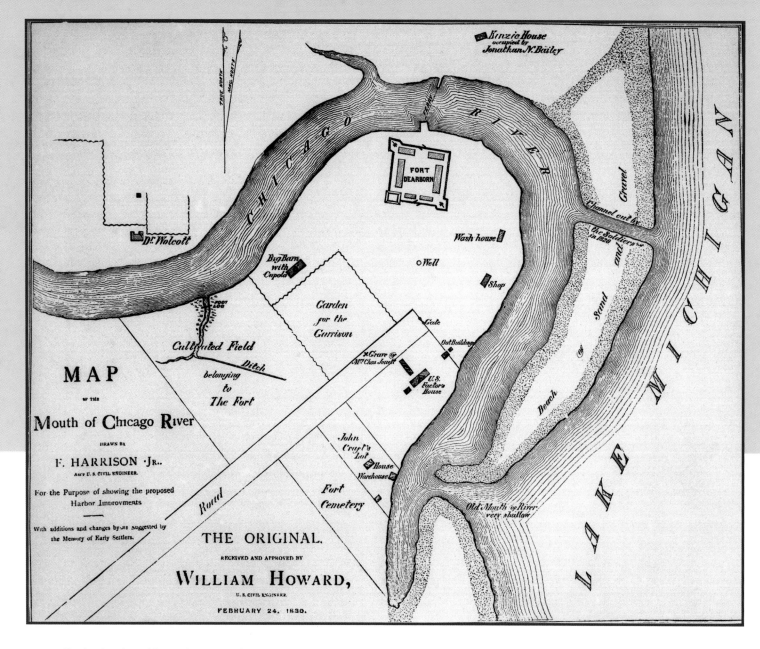

MAP

OF THE

Mouth of Chicago River

DRAWN BY

F. HARRISON ·JR..

ASS'T U.S. CIVIL ENGINEER.

For the Purpose of showing the proposed
Harbor Improvments

With additions and changes by us suggested by
the Memory of Early Settlers.

THE ORIGINAL.

RECEIVED AND APPROVED BY

WILLIAM HOWARD,

U.S. CIVIL ENGINEER.

FEBRUARY 24, 1830.

Map of the Chicago River
by F. Harrison Jr., 1830. Ferry
service was available between
the southern bank at Fort
Dearborn and the northern
bank at the Kinzie house.

originally dug by the soldiers of Fort Dearborn, but they rapidly filled in due to the prevailing Lake Michigan currents and storm surges. Additional rounds of dredging soon followed, as did the construction of piers projecting outward from the northern and southern edges of the Chicago River into Lake Michigan. A surprising consequence of these piers was the massive deposition of sand along the northern pier. This sand accumulation actually resulted in a significant increase in the amount of available land in Chicago from 1834–1869. A breakwater and modern harbor were constructed by the late 19th century, finally solving Chicago's problem with sedimentation at the mouth of the Chicago River.

The expanding city was divided into plots of land, in large part to help finance a proposed canal across the

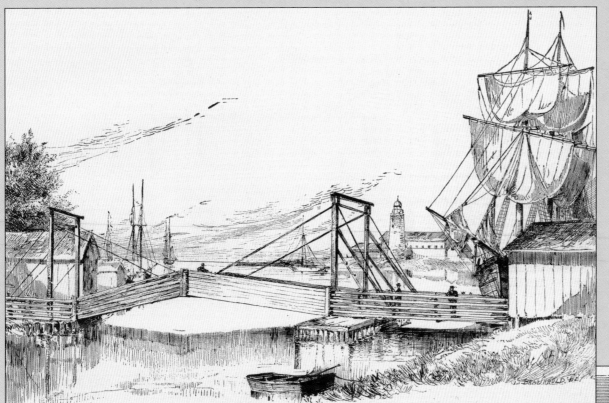

The drawbridge at Dearborn Street, looking eastward, 1834. By the early 1830s, sailing vessels began docking along the Chicago River, assisted by the eventual construction of a lighthouse near the harbor. Construction of movable bridges would be required to handle the passage of boats along the waterway.

A depiction of the Flood of 1849, which destroyed nearly all of the bridges and boats along the Chicago River's South and Main Branches.

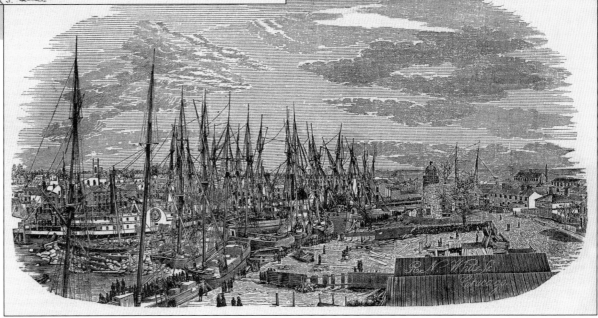

Chicago portage. An increase in construction along the Chicago River necessitated easier ways to cross it, and ferry service started in 1829, while floating bridges and drawbridges were constructed in the early 1830s. These early structures were built with wooden frames and thus had extremely short lifespans. Disaster also played an important role in their demise.

On one tragic day in 1849, nearly every bridge and vessel moored along the Chicago River was destroyed after an ice jam caused the surging waters of the Des Plaines River to cross the subcontinental divide and flow into the Chicago River toward Lake Michigan. The city quickly mobilized and rebuilt its bridges, an act that was repeated 22 years later, after the Great Chicago Fire.

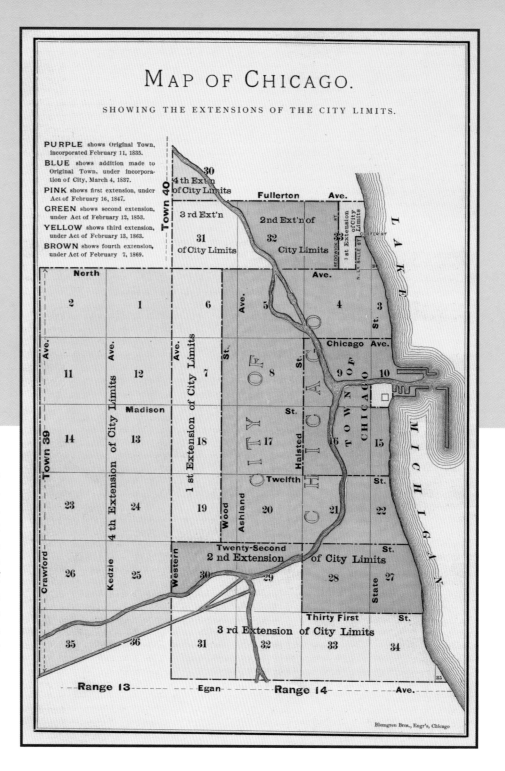

Map of Chicago showing the expansion of the city limits from 1833 to 1869. The Illinois & Michigan Canal can be seen at the bottom left, Goose Island is now visible along the North Branch, and piers, wharves, and a breakwater are evident along the harbor.

The city continued to rapidly expand along the course of the Chicago River, extending to the north, south, and west. Shipments of wheat, livestock, wood, and metal increased dramatically. Wharves and docks were built along the river to handle the corresponding increase in maritime traffic. Soon, the North Branch of the Chicago River even had its own island. Goose Island, just north of the Main Branch, was created when a second channel was dredged by one of Mayor Ogden's businesses. Bricks were made with the excavated clay. Formerly a home to Irish immigrants, Goose Island eventually became a haven for factories and industrial operations.

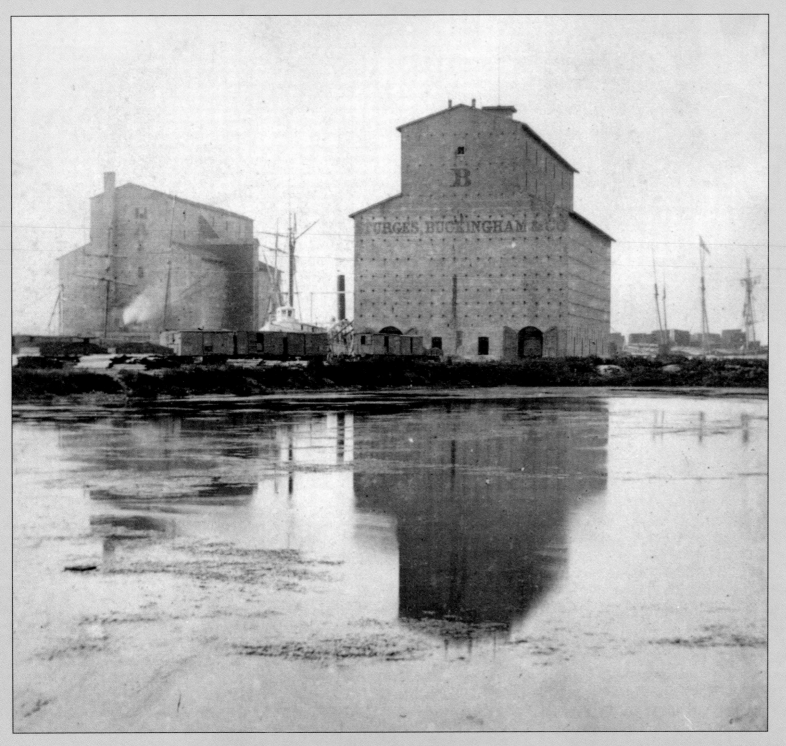

◄

The massive Sturges,
Buckingham & Co.
grain elevators, located
at the mouth of the
Main Branch

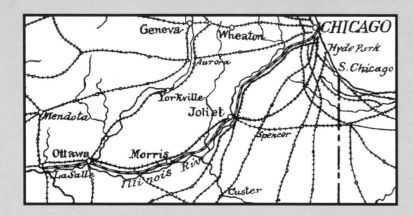

▲ Map of the Illinois & Michigan Canal, circa 1887. The canal ran from Chicago (upper right) toward LaSalle (lower left). Many rail lines crossed the landscape by this time.

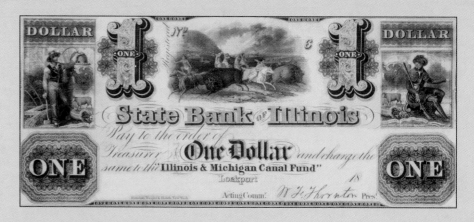

▲ Illinois & Michigan Canal Fund stock certificate, issued by the State Bank of Illinois

The Illinois & Michigan Canal

Over a century and a half after Joliet imagined a canal connecting the Chicago River with the Des Plaines and Illinois River systems, the people of Chicago and the State of Illinois were up for the challenge—a task that would take more than 25 years to complete, with countless obstacles to overcome. The possibility of a canal influenced the placement of Illinois' northern border in 1818, such that any waterway would fall under the jurisdiction of a single state's governance. The Illinois & Michigan (I&M) Canal was authorized in 1822 by Congress, and parcels of land along the canal's 96-mile course were granted to the State of Illinois in order to generate revenue for the project. Construction of the I&M Canal, however, was delayed numerous times, as Illinois possessed inadequate resources to ensure the project's completion.

The original plan called for a "deep cut," in which substantial bedrock would be removed from the bottom of the canal near its summit toward the Des Plaines River. This deep cut was designed to overcome the subcontinental divide, thereby enabling the canal to be fed directly by Lake Michigan. This costlier plan, however, was abandoned in favor of a "shallow cut," in which the canal was fed by surrounding rivers. Near Chicago, the canal would be flushed with water from the South Branch of the Chicago River through the action of massive steam pumps at Bridgeport. This compromise dramatically reduced the amount of money required to complete the I&M Canal.

Construction finally began in 1836, although it was halted numerous times in the early 1840s due to economic depression. Financing was eventually arranged, and a board

of trustees was appointed to serve until all debts were repaid. Construction resumed shortly thereafter, and the I&M Canal was completed by 1848, a generation after Congress provided initial authorization. Final cost for the canal was more than $6 million. The canal was 60 feet wide but, remarkably, only 6 feet deep. At the many locks along its course, the canal narrowed to less than 20 feet across.

The I&M Canal transported a tremendous amount of raw materials through the region, including millions of bushels of grain in the first few years alone. Land sold to help finance its construction also dramatically influenced the growth of many cities throughout Illinois. The I&M Canal's completion, however, coincided with the rise of railroads—transportation that provided faster, year-round service that was not confined to the limited course

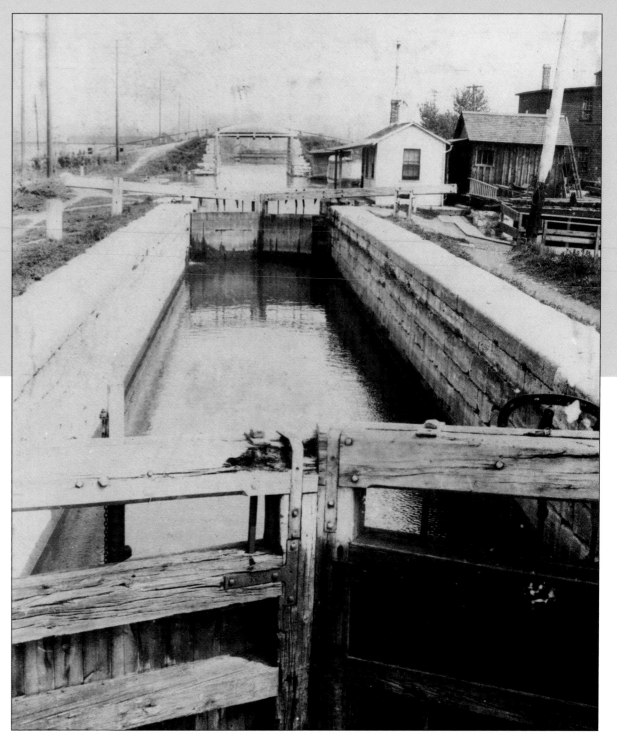

One of the many locks along the historic
Illinois & Michigan Canal, circa 1900–1910

of waterways. Numerous railroads directly competed with the I&M Canal, and they quickly usurped all of the passenger traffic, as well as much of the commercial loads carried along the canal. Despite the intense competition from the railways, however, a substantial amount of raw materials continued to be transported along the I&M Canal into the late 19th century.

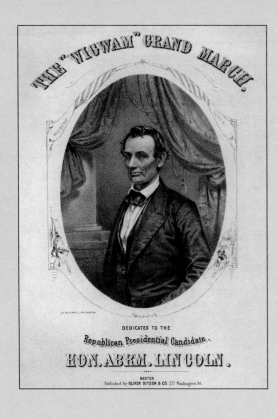

◄ Abraham Lincoln was nominated to be the Republican presidential candidate in 1860 at the Wigwam, a building along the Chicago River.

► The Wigwam

Chicago in the Political Spotlight

By the mid-1800s, Chicago and St. Louis had emerged as important commercial centers linking the eastern and western United States. They soon found themselves at the center of a debate over the federal government's responsibility to protect and improve the inland waterways. In 1846, Congress passed a harbor bill designed to allocate government expenditures to improve inland harbors and rivers, but it was vetoed by President James K. Polk, a vehement opponent of the use of federal resources for this purpose. The I&M Canal was nearly complete, and commerce along the Great Lakes and western rivers was expected to grow exponentially. Inland trade now equaled U.S. exports, and there was growing sentiment that resources should be directed toward securing and enhancing these commercial routes.

Representatives from across the country gathered in the young city of Chicago in 1847 for the National River and Harbor Convention to voice their concerns, all the while raising Chicago's national prominence and placing a spotlight on commerce through the Chicago River.

As described by William Mosley Hall in his compiled account of the conference, a truly colossal parade marked opening day, with over 5,000 people marching through a city of only 16,000 inhabitants. Prominent national speakers took the podium and Mr. Hall discussed the importance of constructing a railroad to the Pacific Ocean. Daniel Webster, in his letter to the convention, emphasized that government regulation of domestic waterways was truly an issue of national importance. A young

Abraham Lincoln, recently elected to Congress and a "tall specimen of an Illinoian" according to newspaper editor Horace Greeley, addressed the convention on his first visit to Chicago.

Thirteen years later, Abraham Lincoln would be selected as nominee for president of the United States. This nomination took place at the Wigwam, a large building along the Chicago River constructed for the 1860 Republican National Convention. In less than 30 years, Chicago had gone from a village of 300 to a city of more than 100,000 and host to one of the country's most important political conventions. Chicago's early successes would inspire remarkable growth, with the population tripling in the decade to follow.

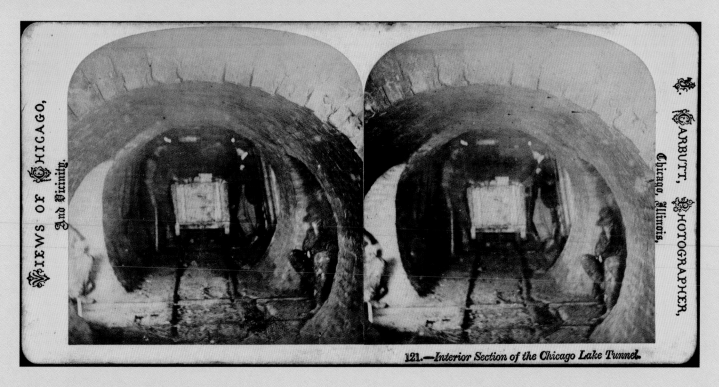

VIEWS OF CHICAGO, and Vicinity.

CARBUTT, PHOTOGRAPHER, Chicago, Illinois.

121.—Interior Section of the Chicago Lake Tunnel.

◀ Stereograph of workers inside the Chicago Lake Tunnel

From Fetid to Fresh: Chicago Improves Its Drinking Water

The rapid growth of Chicago, however, came at the expense of the Chicago River's cleanliness. The water was soon polluted with the filth and sewage of the city's inhabitants, businesses, and stockyards. A terrible public health crisis was born. In 1832, fear of a cholera epidemic led to the first public health ordinance in Chicago, an attempt at prohibiting the dumping of waste into the Chicago River. But cholera arrived anyway. An epidemic in 1849, rumored to have arrived with passengers of the *John Drew*, a boat from New Orleans, killed hundreds of people, and numerous outbreaks of disease followed over the coming decades.

In a very ambitious plan to install sewers throughout downtown Chicago, many buildings were actually raised four to seven feet above their foundations beginning in the mid-1850s. Sewer pipes were placed below the streets and sidewalks, but storm water and sewage still drained directly into the river, only exacerbating the problem the sewers were meant to solve. The Chicago River had a terrible stench, one that was carried right through the heart of downtown Chicago. The city obtained most of its fresh water from the lake, although polluted Chicago River water frequently reached the newly constructed water intake pipes projecting hundreds of feet from shore. Chicago desperately needed both a better way to obtain drinking water and a better way to dispose of its sewage.

An initial solution to Chicago's water supply problem was an ambitious plan to dig a water intake tunnel under Lake Michigan extending two miles from shore, a far stretch from the polluted mouth of the Chicago River. Spearheaded by famed city engineer Ellis Sylvester Chesbrough, construction of the Lake Tunnel began in 1864. Progress was slow, often less than a dozen feet per day. The working environment was dark and the tunnel so long that air needed to be pumped inside of it to prevent the asphyxiation of workers. Fear of collapse was a constant concern. Mules and rail carts were used to remove the excavated soil.

At the end of the tunnel, a mammoth water intake facility (called the "crib") required almost half a million feet of timber and was reinforced with iron to withstand the brutal Lake Michigan winter storms. In 1865, the crib's preassembled shell was floated from its construction site to its final home in Lake Michigan, where it was filled

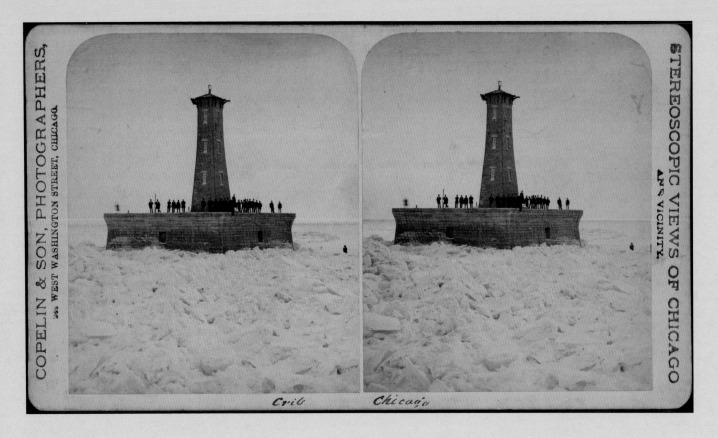

COPELIN & SON, PHOTOGRAPHERS, 141 WEST WASHINGTON STREET, CHICAGO

STEREOSCOPIC VIEWS OF CHICAGO AND VICINITY.

Crib Chicago

A stereograph from 1875 shows the massive Lake Tunnel crib, located two miles from the Chicago shoreline.

The Chicago Waterworks (left) and its landmark Water Tower (right) located at the intersection of Chicago and Michigan Avenues. The Water Tower was spared from destruction in the Great Fire of 1871.

with stones until it settled gently into place. At this point, digging of the tunnel proceeded from both directions, and the two tunnels miraculously joined on November 24, 1866. With the additional construction of the waterworks and Chicago's landmark Water Tower in 1867–1869, plus a second Lake Tunnel in 1872, the city of Chicago would soon have a new water supply, as well as a renewed belief that anything was possible with ingenuity, hard work, and—most importantly—financial support.

Shortly after the construction of the Lake Tunnel, three passenger tunnels were constructed under the Chicago River to help facilitate pedestrian, carriage, and rail crossings. Maritime traffic on the waterway was also alleviated. Tunnels at Washington Street on the South Branch and LaSalle Street on the Main Branch were built between 1867

and 1871 at a cost of more than half a million dollars each. An additional rail tunnel was constructed at Van Buren Street in 1894. While the Washington and LaSalle Street tunnels did help to ease traffic bottlenecks that occurred as bridges opened for the passage of ships, they also served as important escape routes during the Great Chicago Fire.

Another approach to improving the overall quality of drinking water in Chicago involved an initial attempt at "reversing" the Chicago River. By finally dredging the summit of the I&M Canal (the "deep cut") and pumping even more water into it from the river's South Branch, portions of the Chicago River were expected to flow southward instead of into Lake Michigan. This ambitious plan was begun in 1865, almost 20 years after the I&M Canal originally opened. A new pumping works at Bridgeport

was also constructed, and a new water tunnel at Fullerton Avenue on the North Branch was excavated. The canal, however, proved too inadequate to handle the additional flow brought by heavy rains. Water conditions along the Chicago River continued to be intolerable. Before something could be done, however, Chicago would first have to contend with a much greater tragedy.

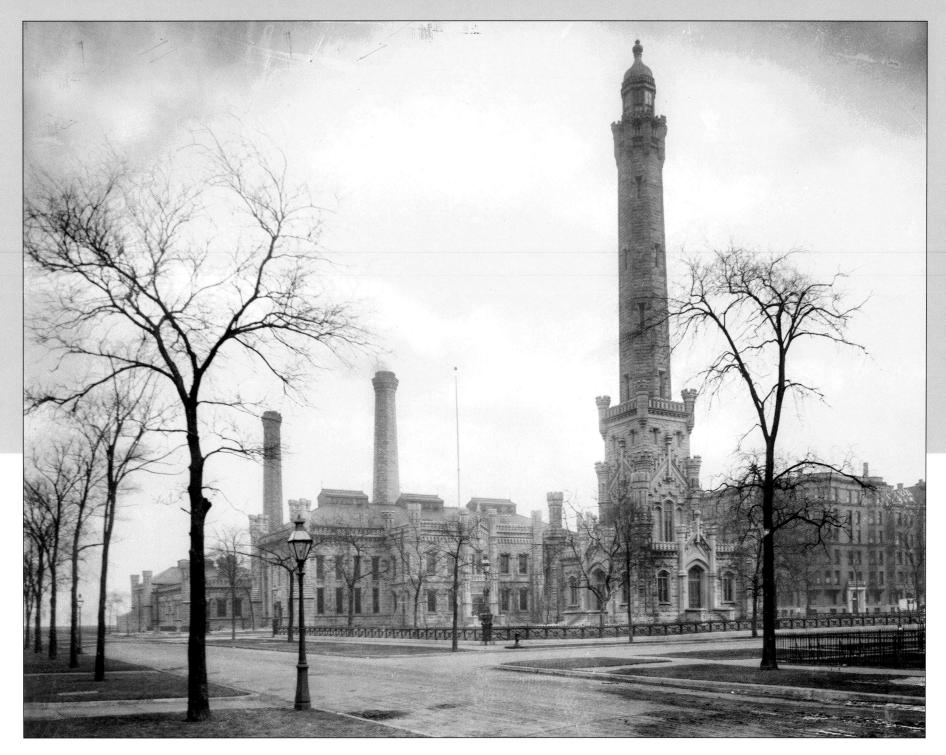

By 1865, the Chicago River was overwhelmed with boat traffic as barges, steam-powered vessels, and sailboats from the I&M Canal all competed for space on the water and mooring along the river's edge.

The Washington Street Tunnel allowed pedestrians to quickly pass underneath the busy and congested Chicago River. Movable bridges opened frequently to permit the passage of boats along its course.

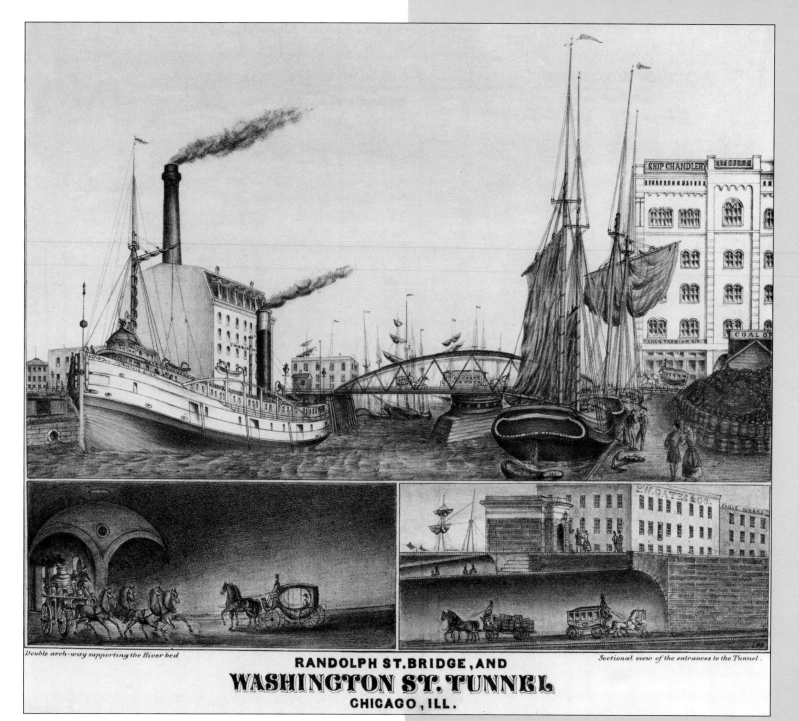

Double arch-way supporting the River bed

Sectional view of the entrances to the Tunnel.

RANDOLPH ST. BRIDGE, AND

WASHINGTON ST. TUNNEL

CHICAGO, ILL.

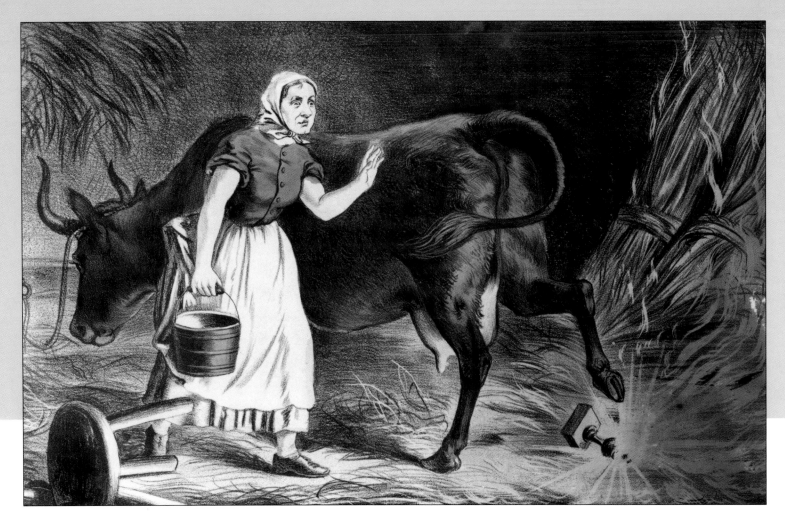

◀

Mrs. O'Leary's cow

▶

The Bridges and tunnels across the Chicago River provided an escape from the blazing inferno that quickly spread through the business district. The fire would soon cross the river and ravage the North Side community as well.

The Great Chicago Fire

On October 8, 1871, the city of Chicago experienced the unthinkable: the near total destruction of the city. While the initial event that caused the Great Fire will always remain a mystery, it is clear that a number of factors contributed to its enormity. The summer of 1871 was dry and the city was a tinderbox. The construction of many wood-framed buildings made Chicago's rapid expansion possible; easily constructed, these building were also easily demolished in the fire's uncontrollable flames. Numerous smaller fires also occurred that summer; one ignited the day before the Great Fire, only a few blocks from the barn of the now infamous Mrs. O'Leary's cow. Popular legend states that the cow accidentally knocked over a lantern, thus starting the Great Chicago Fire. Recent speculation, however, points to human involvement as the cause of the disaster.

No matter how the fire started that Sunday night, once ignited, the flames spread rapidly. Updrafts quickly carried burning embers northward and then eastward across the South Branch of the Chicago River. Overnight, Chicago's entire financial district burned. Citizens fled across the Chicago River, over bridges and through passenger tunnels, hoping that the fire would not spread across the water. While many bridges across the Chicago

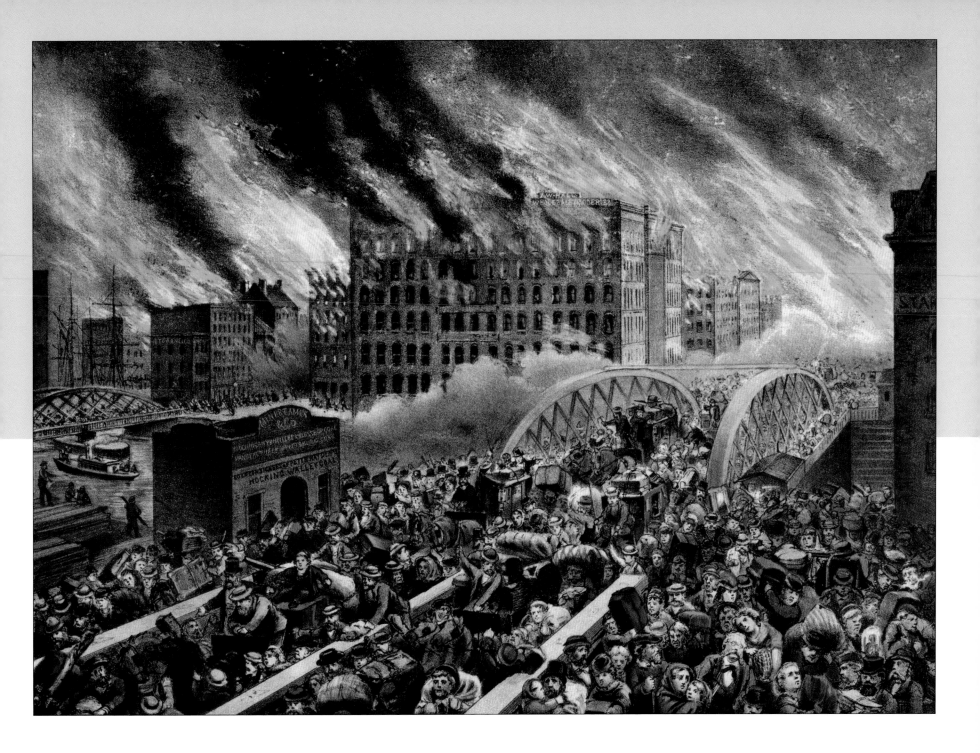

Chicago Rises Along the Riverbanks (1800–1900) **33**

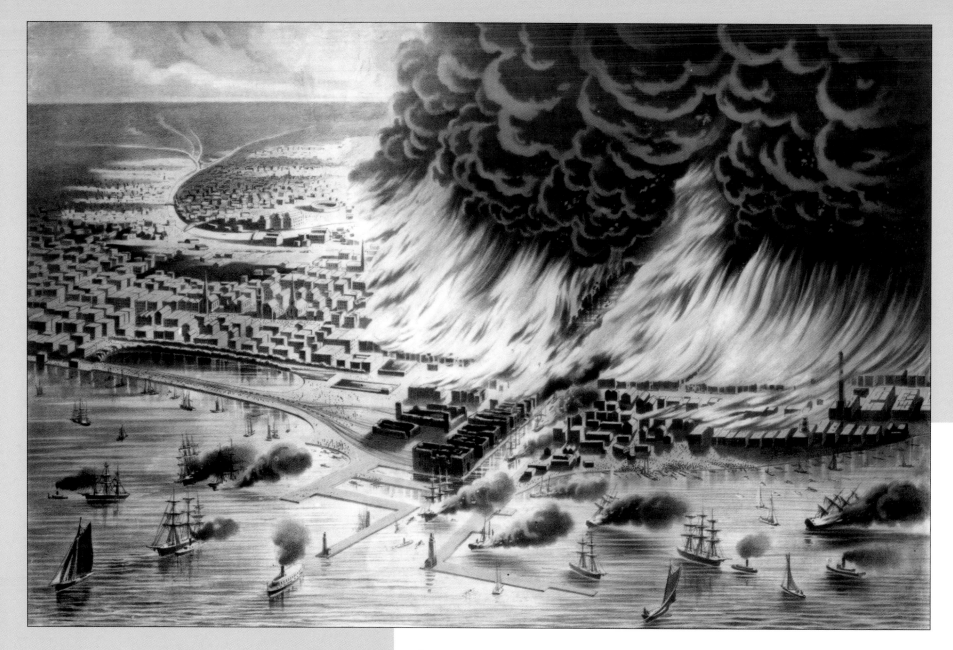

▲ Fortunate citizens fled to the safety of Lake Michigan by boat, while others ran toward the shoreline or away from the flames as the Great Fire engulfed the city behind them.

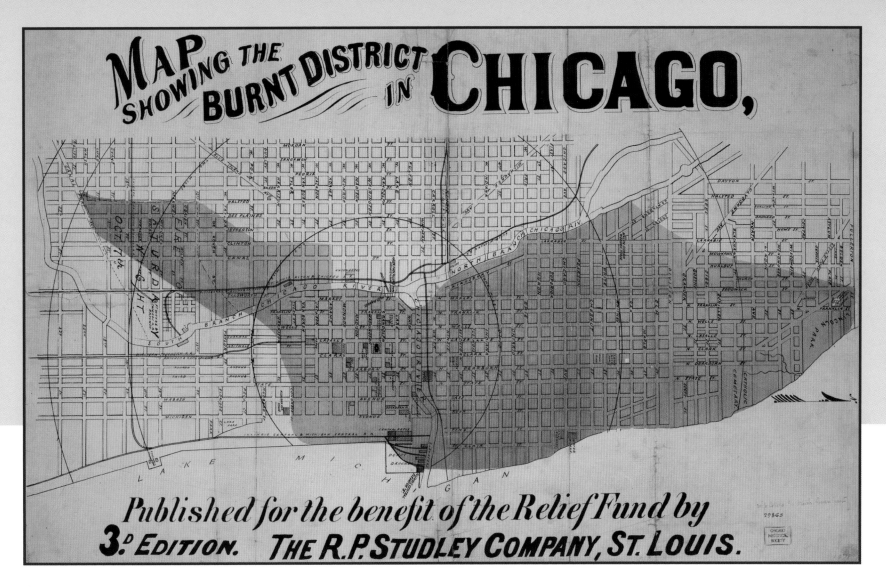

MAP SHOWING THE BURNT DISTRICT IN CHICAGO,

Published for the benefit of the Relief Fund by

3.D EDITION. THE R.P. STUDLEY COMPANY, ST. LOUIS.

▲ Map showing the extent of Chicago's destruction by the Great Fire.

River soon burned, others, like the Madison Street swing bridge, survived due to the heroism of dedicated bridge tenders. Unfortunately, the fire crossed the Chicago River's Main Branch overnight and spread rapidly across the city's north side throughout the following day.

By the time the fire subsided 24 hours later, over 300 people lost their lives and more than 100,000 Chicago citizens were homeless. The city was in shambles. Images of the ravaged city published in books and newspapers across the globe bear witness to its absolute devastation.

Would the Great Fire destroy Chicago's potential for growth? As it happened, quite the opposite was true. Before the fire, Chicago's population was 300,000; less than a decade later it would grow to 500,000, and it doubled yet again over the following 10 years. The Great Fire destroyed 8 bridges, but many new bridges were constructed in the next 2 years. In fact, by 1884, more than 30 bridges crossed the Chicago River, most of them constructed *after* the fire. Corresponding improvements to the city's water distribution system also occurred during this time. Chicago did not just rebuild; it reinvented itself.

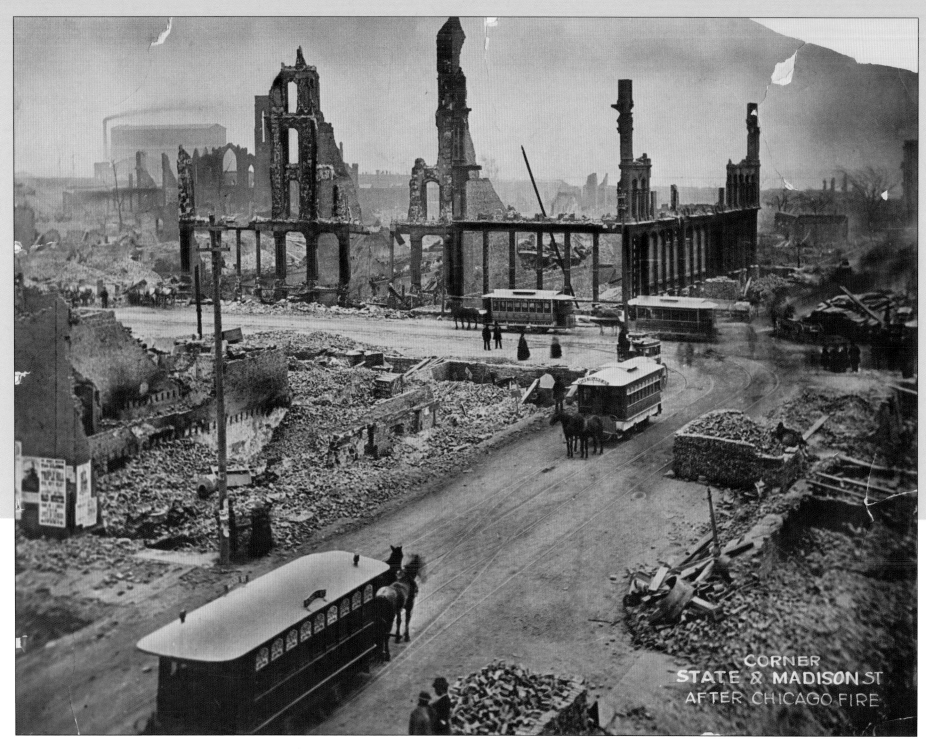

CORNER
STATE & MADISON ST
AFTER CHICAGO FIRE

Rubble and embers were all that remained of downtown following the fire. This photograph looks eastward toward Lake Michigan. The large grain elevators still stand in the far distance (left).

This small fire wagon, here refilling along the Chicago River's edge, would have done little to stop the Great Fire once it had started.

Center-swing bridges lined the course of the Chicago River. They were quickly replaced after the Great Fire. Work on 12 bridges was largely completed by mid-1872, with many more to follow in the next decades.

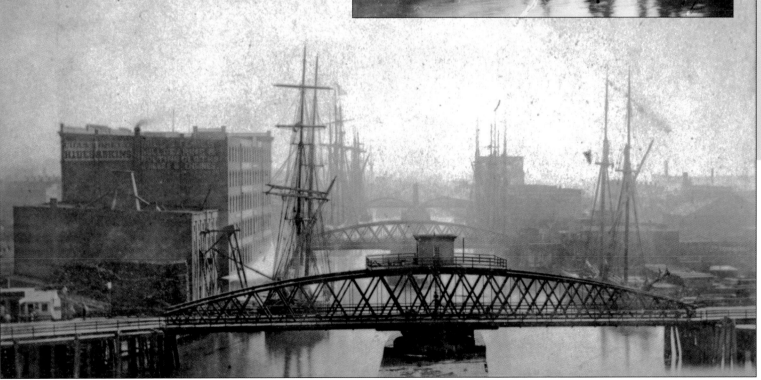

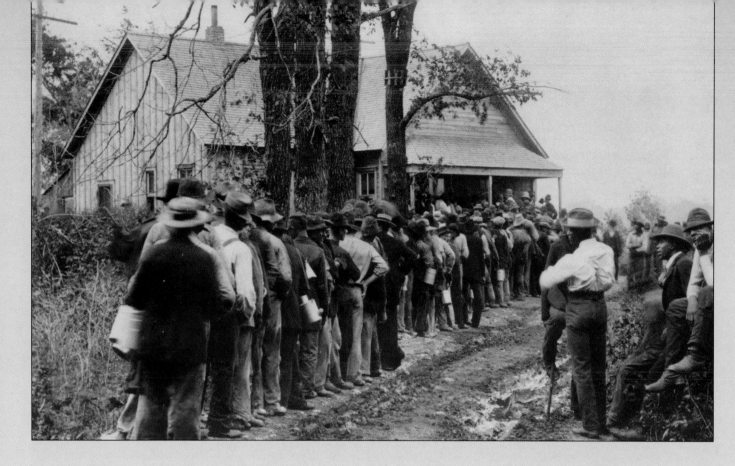

◀

Men waiting in line for work. Construction along the Chicago Drainage Canal was a major source of employment for many Chicagoans in the 1890s.

▶

Construction of the canal involved blasting away the bedrock with dynamite, then removing the rubble with shovels, large cantilevers, conveyer belts, and railcars.

The Sanitary and Ship Canal

After the postfire reconstruction of Chicago, attention again focused on solving the problem of sewage disposal. Despite construction of new water intake tunnels and the I&M Canal deep cut, waterborne illness continued to torment the city. Something had to be done to protect the health of Chicago, and a bold but controversial solution was proposed—the construction of a massive canal to permanently reverse the flow of both the Main and South Branches of the Chicago River, draining them instead into the Des Plaines River and channeling all of Chicago's sewage toward the Illinois and Mississippi Rivers instead of Lake Michigan.

The idea for this new canal was spearheaded by the Citizen's Association of Chicago, and the plan would

ultimately require approval from the state government. A subsequent 1887 report from the Drainage and Water Supply Commission formally called for the canal's construction. A municipal sanitary district was proposed to implement the plans and coordinate financing for the project. After passage of an enabling act and voter approval in 1889, the Sanitary District of Chicago was born. The Illinois General Assembly heard testimony regarding the volume of water expected to flow through the canal. Would pollution kill aquatic life in the Illinois and Mississippi Rivers? Would the canal drain the entire Great Lakes basin? Could such a massive project ever be constructed?

A separate movement promoting the construction of a deep and wide shipping canal to connect Lake Michigan with the Illinois and Mississippi River systems also helped push the idea of a sanitary canal through state and federal approval. Indeed, commercial maritime traffic continued to increase on the Chicago River, with ships growing even larger to transport the ever-expanding loads of imported and exported goods through Chicago. By the late 1890s, the Chicago River was second only to New York in total tonnage of goods transported. But the river would need substantial improvements in order to accommodate this traffic, and organizations such as the Association for the Improvement of the Chicago River

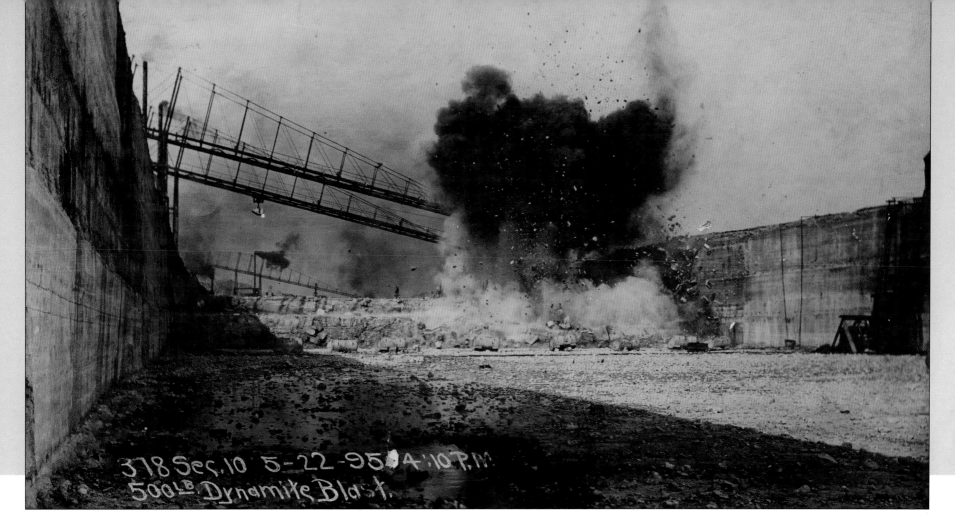

378 Sec. 10 5-22-95 4:10 P.M. 500 LB Dynamite Blast.

helped by promoting its dredging and widening. This was conducted as part of the River and Harbor Act of 1896. One attendee at the river improvement meeting that year proclaimed that the condition of the Chicago River and harbor was a "disgrace to modern civilization." A federal requirement mandated that river tunnels on the Main Branch and South Branch needed to be lowered to accommodate maritime traffic to a depth of 26 feet. Center-swing bridges needed to be replaced with less obstructive bascule bridges. These improvements to the Chicago River meant that the massive new canal would have a bizarre but functional dual purpose: to carry away the waste of Chicago's sewers *and* to transport the goods

of modern shipping to and from the commercial center of America.

Not everyone was pleased, however, with the possibility of diverting all of Chicago's sewage into the Illinois and Mississippi Rivers. Based on analyses of the waste matter content in the Chicago River, as well as congressional testimony detailing the volume of water required to safely flush it away from Chicago, some argued that the canal needed to be untenably large in both size and flow. Numerous downstream cities including St. Louis threatened legal action to halt the canal's construction. There was a very strong possibility that the canal would never be completed due to continued litigation and governmental interference.

Construction of the canal finally began on "Shovel Day," September 3, 1892. The canal meant jobs, over 8,000 of them, mostly filled by immigrants and Chicago laborers. Cantilevers, hydraulic dredges, dynamite, conveyor belts, horses, cranes, cables, steam shovels, drills, railcars, sweat, and muscle all worked together to carve through the glacial drift and bedrock to an overall depth of 22–35 feet and a width of 160–200 feet. The so-called Drainage Canal dwarfed the nearby I&M Canal. New developments in large-earth excavation, adapted first during construction of the Drainage Canal, proved beneficial in subsequent public works projects around the world. The canal extended from Bridgeport in the east to a

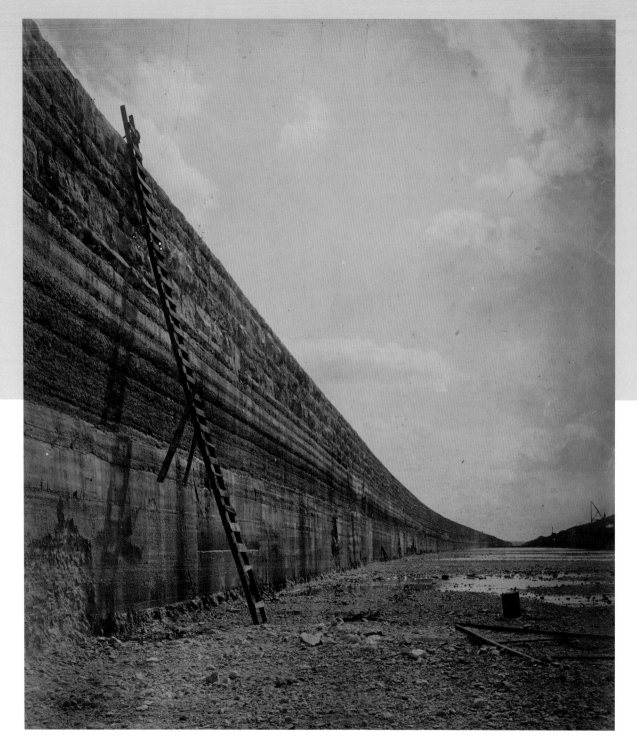

◄

A view from the bottom of the excavated canal

sluice-gate dam and control works at Lockport, 28 miles to the west. Construction uncovered geologic mysteries, long hidden by the passing mass of glacial ice 12,000 years before. Thousands of visitors to Chicago's famous 1893 World's Columbian Exposition came to witness the massive amount of earth being removed for the canal, which now extended as far as the eye could see.

By the time the Drainage Canal was complete, over 40 million cubic yards of earth had been excavated. In its 1895 guide for tourists, the Chicago & Alton Railroad Company hardly exaggerated in stating that this was one of the greatest engineering projects of the century, larger than the Suez Canal, and "one of the most interesting places in the world for the study of glacial geography." In 1899, the Commission on the Chicago River reported that "the future prosperity and growth of Chicago [was]

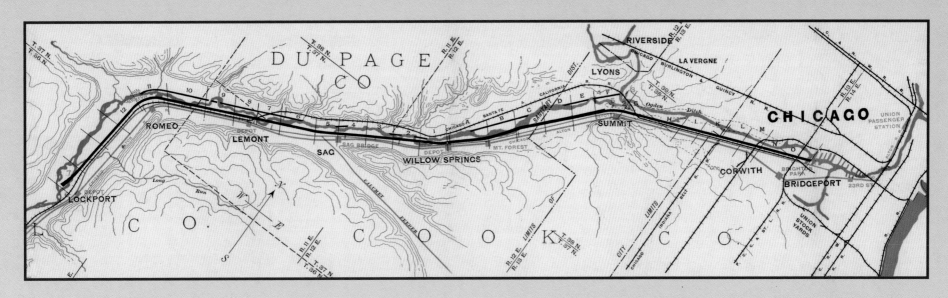

▲ The Chicago Drainage Canal extended from Chicago's Bridgeport community in the east to Lockport in the west. It was later extended to Joliet.

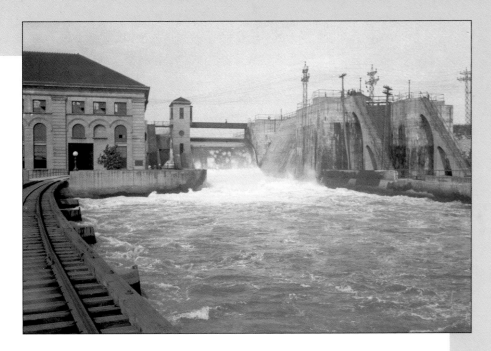

▲ The control works for the canal were located in Lockport, shown here in 1914.

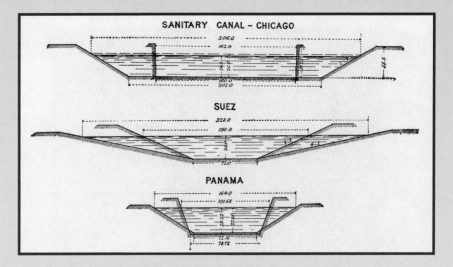

▲ A 1926 engineering diagram demonstrating the size of the Sanitary and Ship Canal compared with other well-known canals around the world

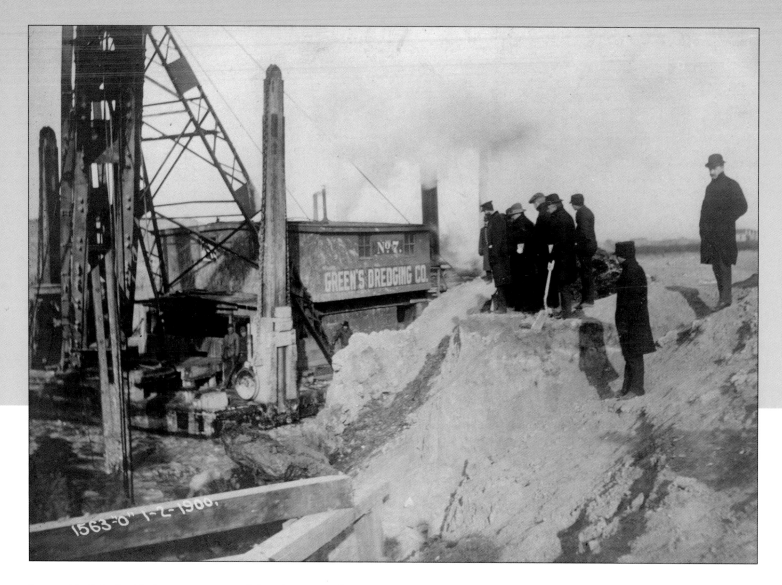

Canal trustees witnessing the first release of Chicago River water into the canal on January 2, 1900

►

Members of the Sanitary District on the *Juliet*, the first boat to travel down the Sanitary and Ship Canal

inseparably linked with the improvement of the Chicago River." They could not have been more correct.

Threat of a legal recourse from the city of St. Louis, fiercely intent on preventing the opening of the canal (and the potential further pollution of the Illinois and Mississippi Rivers), motivated a hurried but hushed opening of the canal. It would be infinitely harder to stop a waterway already flowing than to prevent one from opening in the first place. A group of canal trustees and witnesses quietly gathered on January 2, 1900, to watch the remaining earth and ice be shoveled, blasted, melted, and dredged away from a temporary control dam. The channel started flowing— a process that filled 28 miles of canal in less than two weeks. The Lockport gate was then lowered: the Chicago River now emptied into the Illinois and Mississippi River systems. A few years later, the canal was extended, a new lock constructed, and vessels could now pass all the way to the city of Joliet. The Chicago Drainage Canal was officially renamed the Chicago Sanitary and Ship Canal. When navigational improvements to the Illinois River system were completed in the 1920s and 1930s, the entire region opened to the passage of much larger vessels. There was hope yet again that Chicago's water problem was finally solved.

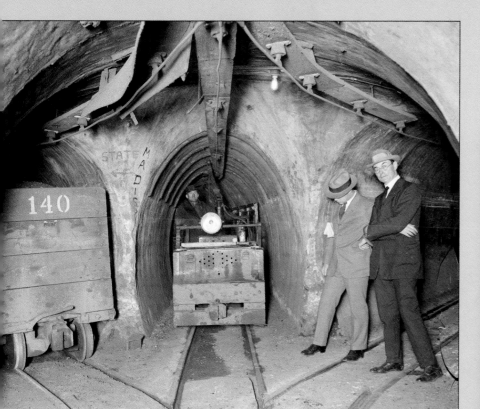

A view from inside the Chicago freight tunnel system, circa 1924

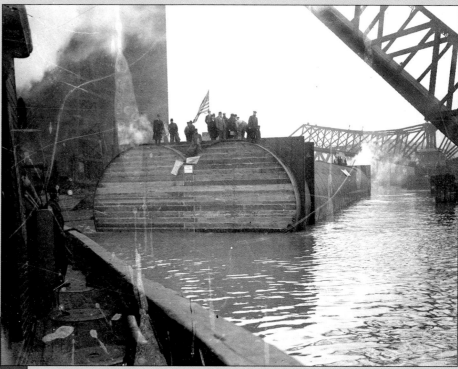

▲ The new LaSalle Street Tunnel floated from its construction site on Goose Island to the Main Branch of the Chicago River, 1910.

◄ Inside the Washington Street Tunnel, 1911

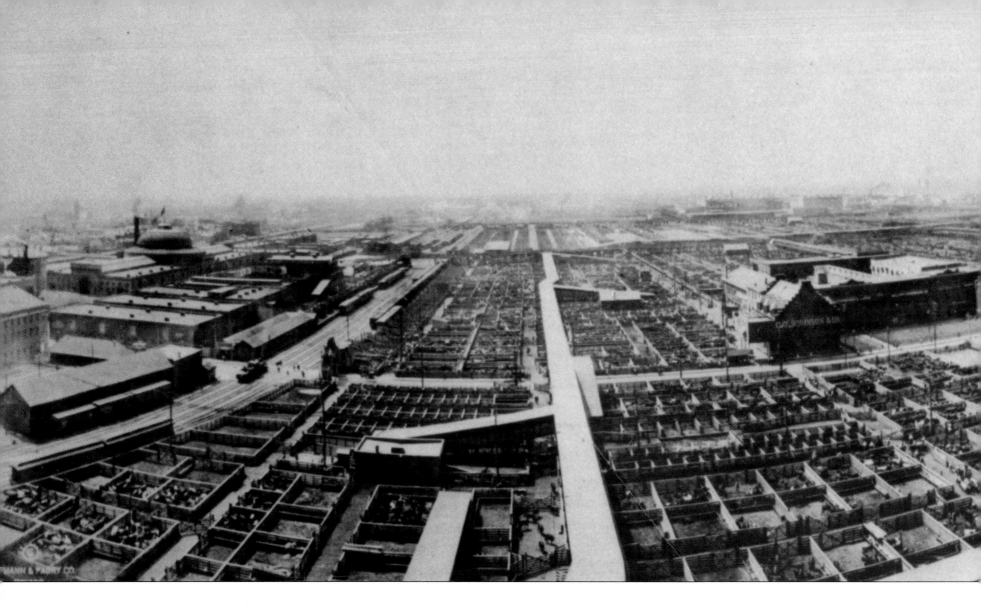

Bubbly Creek and the Stockyards

While pedestrians filled the streets of what was now one of America's largest cities, Chicago was also known as the meatpacking capital of the United States and was therefore "home" to millions of livestock in its stockyards and slaughterhouses. The Union Stockyards were officially opened in 1865 along the South Fork of the Chicago River's South Branch, where they soon expanded to more than 475 acres. At the junction of rail lines and maritime commerce, Chicago was easily accessible to Midwestern cattle and hog farms and thus was a natural location for the stockyards. Tens of thousands of Chicagoans found employment there, where animals were slaughtered under conditions that were at best arduous for the workers, and at worst completely unbearable, inspiring works such as Upton Sinclair's *The Jungle*. Depending on the wind, the pungent odor of the stockyards was noticeable throughout the entire city.

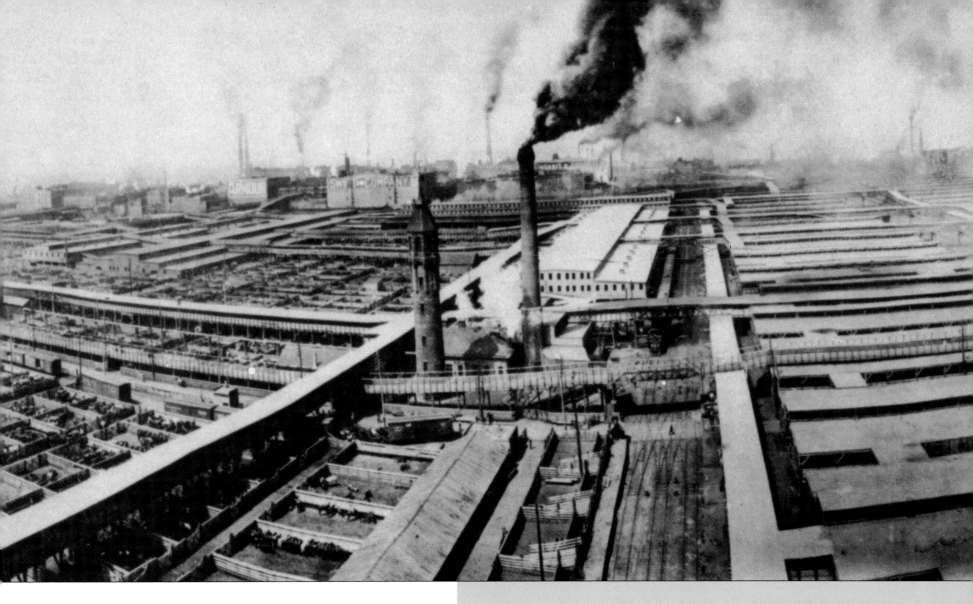

▲ A photograph of the stockyards, circa 1902

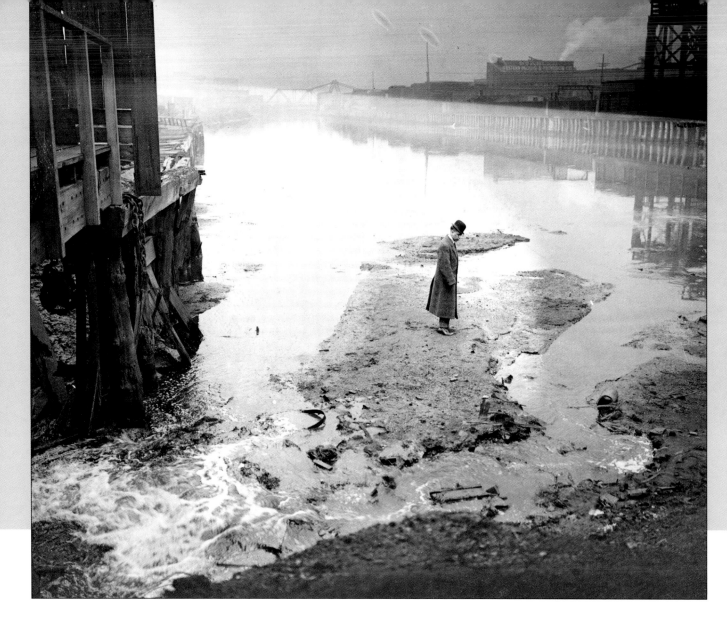

▶ A man observing waste being discharged from the stockyards into Bubbly Creek, 1911

Unfortunately for the Chicago River, refuse from slaughtered animals was routinely dumped directly into the water. This waste contributed tremendously to the Chicago River's terrible condition. The South Fork of the South Branch became known as Bubbly Creek, as decomposing waste matter actually caused bubbles of methane gas to rise from the murky river bottom. The opening of the Sanitary and Ship Canal in 1900, however, greatly improved the flow of water through the South Branch. Improvements in animal rendering, delicately described in a 1921 Sanitary District report on the stockyards as saving "everything but the squeal," meant that far less waste was being dumped into the Chicago River. The stockyards officially closed in 1971. Bubbles still rise to the surface in the South Fork, an enduring reminder of the industry that called Chicago home for more than a century.

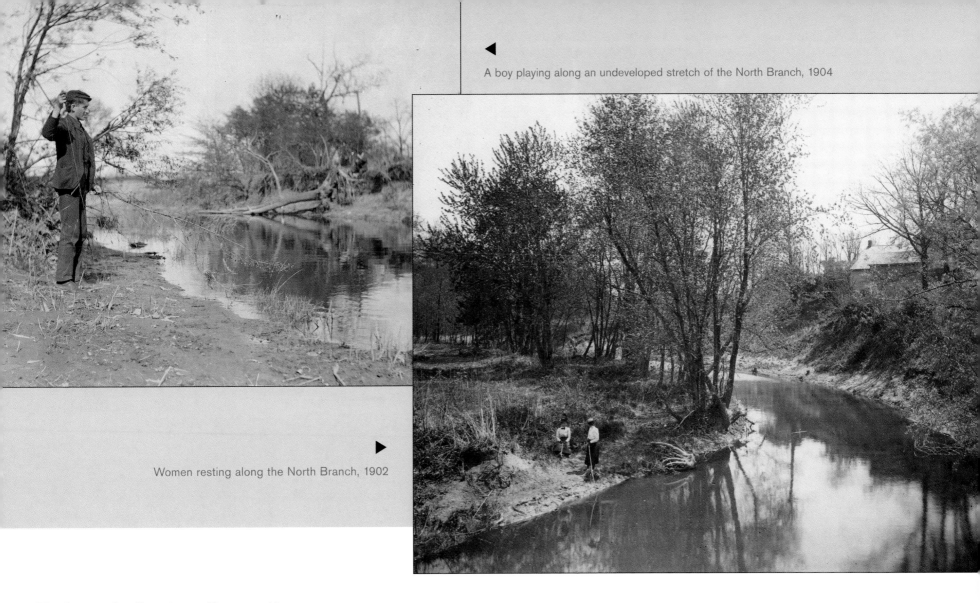

Women resting along the North Branch, 1902

Early 20th-Century Recreation

Despite horrible stories of pollution along the Chicago River, citizens of Chicago still found time for recreation and rejuvenation along the waterway. Much of the North Branch still possessed a quaint, picturesque feeling. It was a place for leisure, picnicking, and even swimming for those trying to escape the summer's heat. In the 1930s, the Civilian Conservation Corps constructed the Skokie Lagoons in the uppermost regions of the North Branch, a transformation that converted the former marshes into a series of flood-controlled lakes. These lagoons are now bordered to the north by the beautiful Chicago Botanic Garden, and they continue to provide Chicagoans an area of natural beauty surrounding the river. Riverview Park, an amusement park near Belmont Avenue on the North Branch, opened in 1904. It entertained visitors along the Chicago River for more than half a century.

Competitors race through downtown Chicago during the annual Chicago River swimming marathon, 1909

Men fishing at the mouth of the Chicago River along North Pier, circa 1915

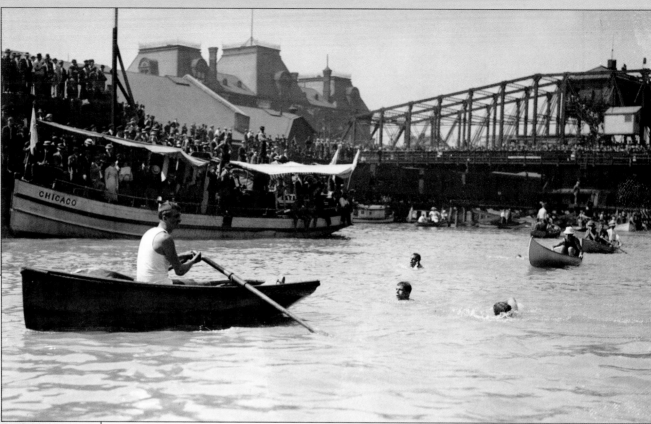

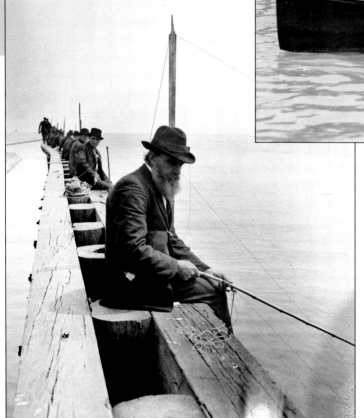

A medal awarded in the 1920 swimming marathon

Recreation along the Chicago River was in no way limited to the North Branch. Fishing was quite common all along the river, despite serious water quality concerns. Fisherman could be seen lining the river's edges, wharves, and piers, especially along the Main Branch where the fresh Lake Michigan water now flowed into the Chicago River. As this small stretch of water was now comparatively clean, Chicago astonishingly was host to annual swimming marathons in the early 1900s, right through the heart of downtown. The entire lakefront, as well as the Municipal Pier and Main Branch of the Chicago River, found itself home to an increasing number of recreational activities. The river continued to support the life of this ever-expanding city.

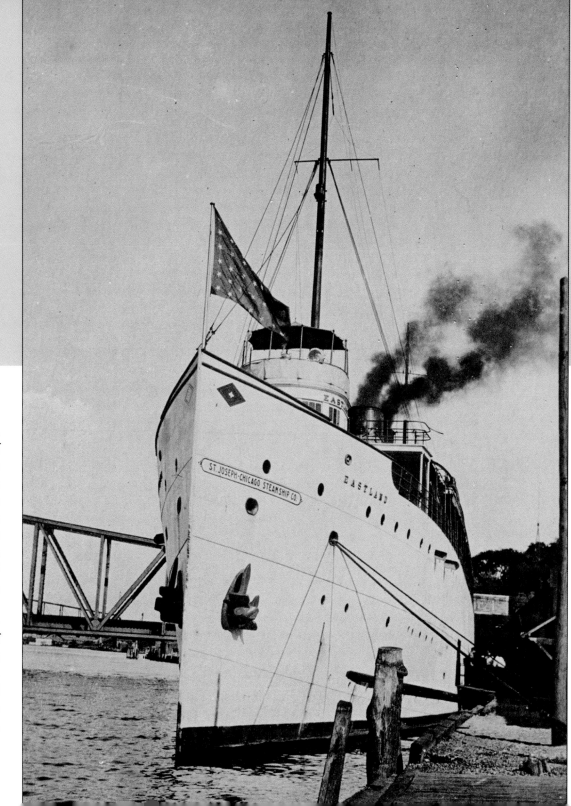

▶

S.S. Eastland before the 1915 disaster

The *Eastland* Disaster

The Chicago River soon witnessed tragedy yet again. On July 24, 1915, over 2,500 employees and guests of Chicago's Western Electric Company were scheduled to travel on the *S.S. Eastland* from downtown Chicago to Michigan City for their annual picnic. In the early 20th century, this maritime journey across Lake Michigan on passenger ships was a common and leisurely way to escape the congested city and visit the natural shores of Indiana and Michigan. On this particular morning, the *Eastland* was waiting at its dock on the Main Branch of the Chicago River between the Clark and LaSalle Street Bridges.

Although the *Eastland* had a history of mishaps, passengers boarded the ship shortly after 7 a.m. in anticipation of a relaxing trip. Captain Harry Pederson and chief engineer Joseph Erickson soon noticed the ship tilting in the water. Early attempts at stabilizing the ship appeared successful and boarding continued. The crew and passengers were completely unaware of the disaster that was about to occur.

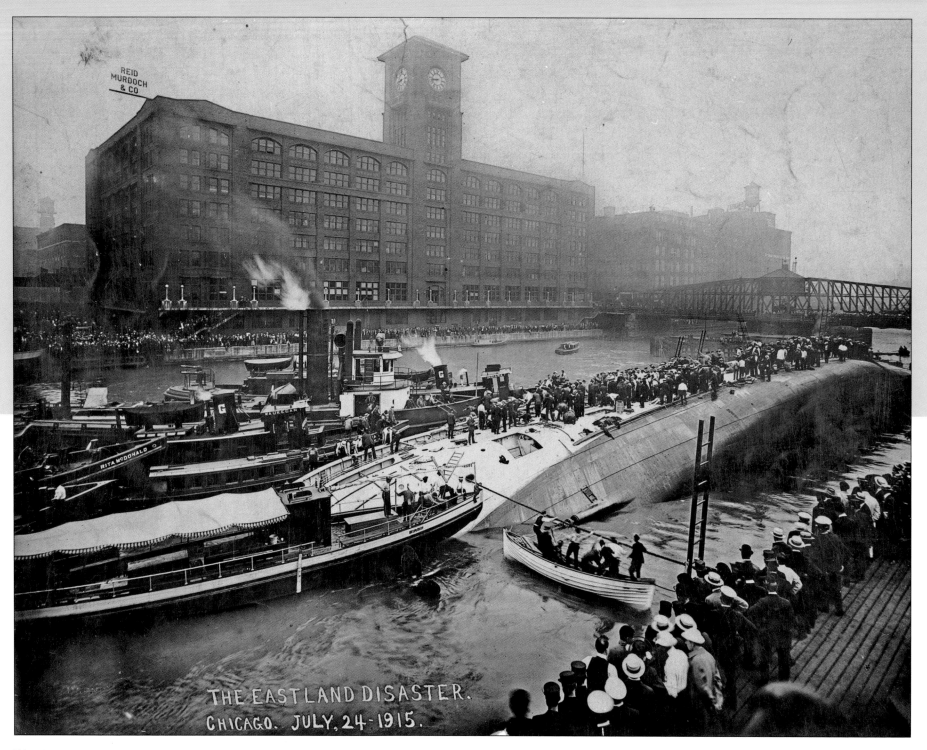

THE EASTLAND DISASTER.
CHICAGO. JULY, 24-1915.

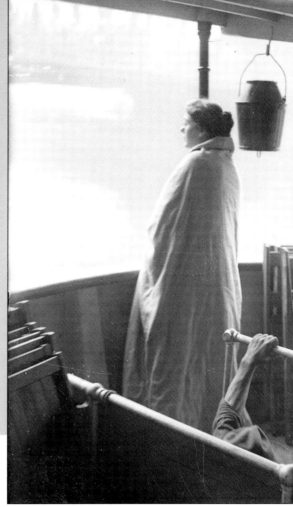

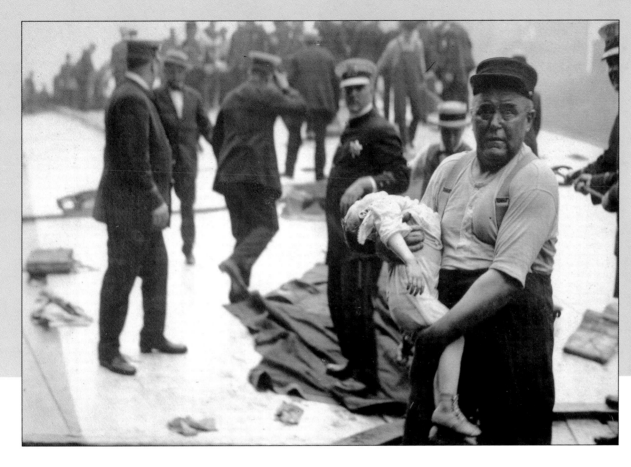

▲ A stunned man holds a child's body pulled from the *Eastland*. This infamous photograph conveys the rescuers' horror and disbelief at the tragedy.

◄

The overturned *Eastland*. Spectators line the shores while rescue and recovery operations surround the ship. Caskets can be seen on a nearby boat (bottom left).

An onboard orchestra continued playing music for entertainment. Within 20 minutes, however, the situation began to worsen as the crew realized that the ship's tilt could not be controlled; capsize was inevitable. Passengers lost their balance as the ship slanted more than 40 degrees to the left. Dishes crashed while many people jumped toward shore or into the water.

Within a few short minutes, the *Eastland* had rolled completely onto its side as water rushed into the ship. Nearby boats and bystanders helped rescue those in the water still clinging to the vessel. In the end, 844 people drowned in the Chicago River's worst maritime tragedy. City officials and relief organizations worked feverishly to provide assistance to the passengers and their families. Morgues were quickly established near the overturned *Eastland* as bodies were pulled from the water. A salvage vessel, *The Favorite*, supplied by the Great Lakes Towing Company, helped to recover the damaged ship. Crowds of spectators flocked to see the tragedy. The *Eastland* was eventually sealed by divers and water was then pumped out of the ship's hull. Towropes were used to turn the ship back upright.

▲ A teddy bear pulled from the water near the disaster

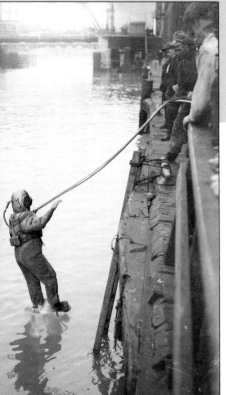

◄ Diver Harry Halvorsen jumps into the river to look for more wreckage from the *S.S. Eastland*.

► Rescuers sort through debris inside of the overturned *S.S. Eastland*. The floor of the boat is visible along the left side of the photograph.

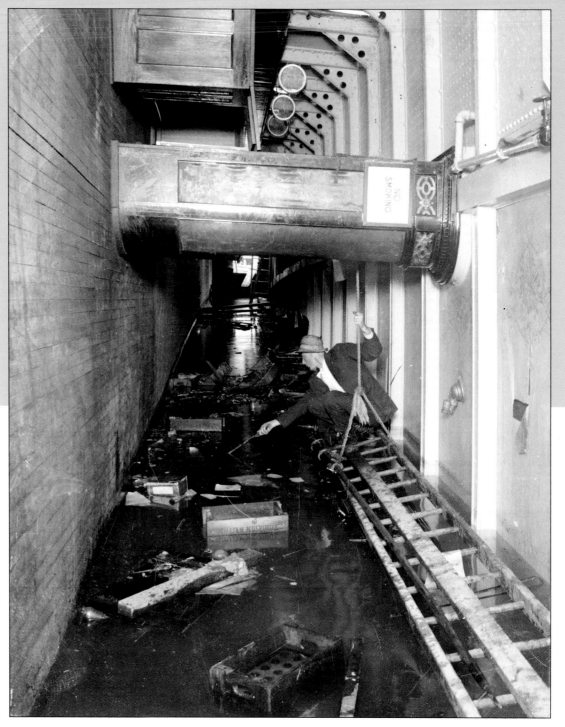

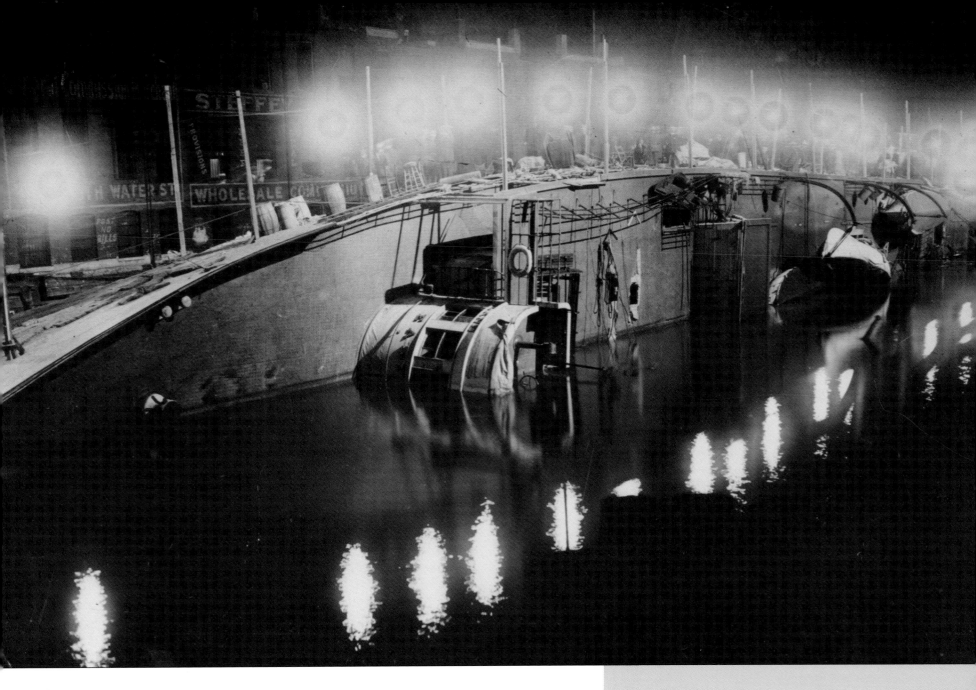

▲ The *Eastland* illuminated at night

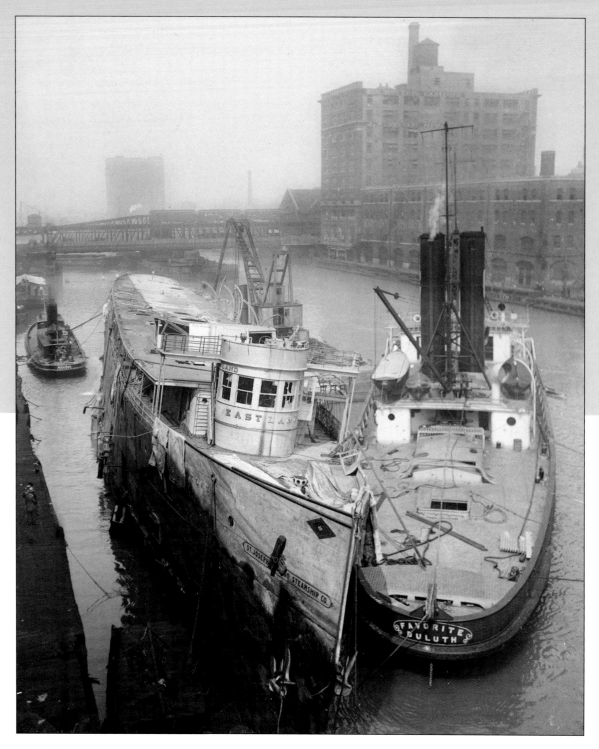

The *Eastland*, now righted,
moored next to the *Favorite*

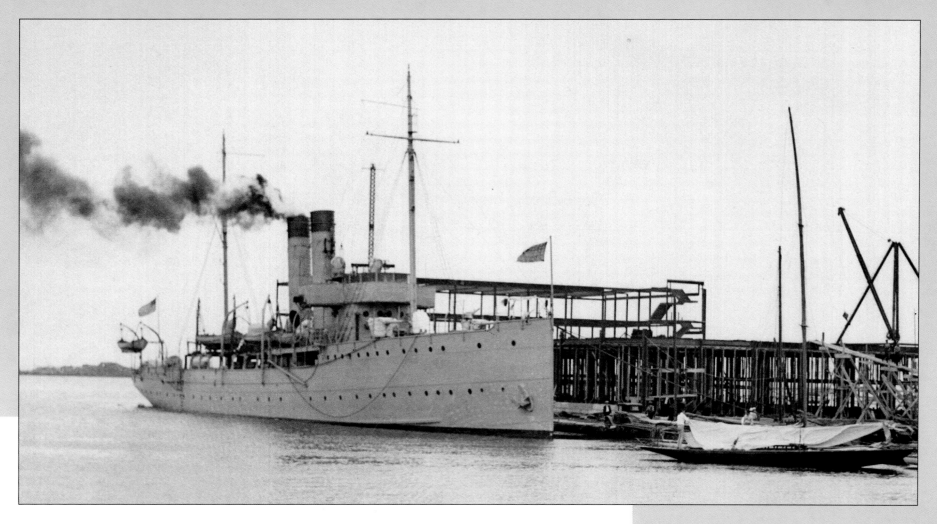

The ultimate cause for the *Eastland* disaster is still debated today. Expert testimony and analysis are presented in George Hilton's *Eastland: Legacy of the Titanic*. The ship was top-heavy and narrow, in part due to harbor constraints in South Haven where it was constructed. The gangways were situated too close to the water. The ballast used to stabilize the ship was notoriously troublesome. The ship was retrofitted with an air-conditioner, and safety modifications required after the *Titanic* disaster three years earlier added a lot of weight. In addition to these constraints, the *Eastland* was also clearly loaded with too many passengers.

Interestingly, the ship was not mothballed but rather reconstructed into the *U.S.S. Wilmette*, a U.S. naval vessel designed for use in World War I. The ship wasn't completed before the end of the war, however, and was used instead by the Navy as a Great Lakes training vessel. To make the story even more intriguing, the *Wilmette* eventually did sink a German U-boat, which had been towed into Lake Michigan after the war. The submarine still rests on the bottom of Lake Michigan. The *U.S.S. Wilmette* was eventually dismantled and sold for scrap, thus bringing to an end the journey of the *S.S. Eastland*.

▲ Rebirth of the *S.S. Eastland* as the *U.S.S. Wilmette*, a training vessel for the U.S. Navy, 1929

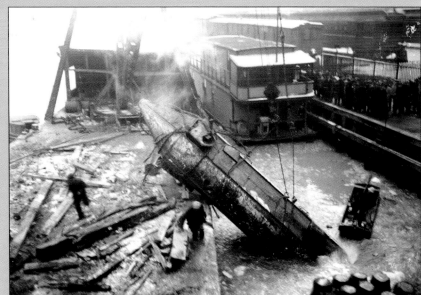

▲ The *Foolkiller* submarine is raised from the bottom of the Chicago River at Wells Street, 1915.

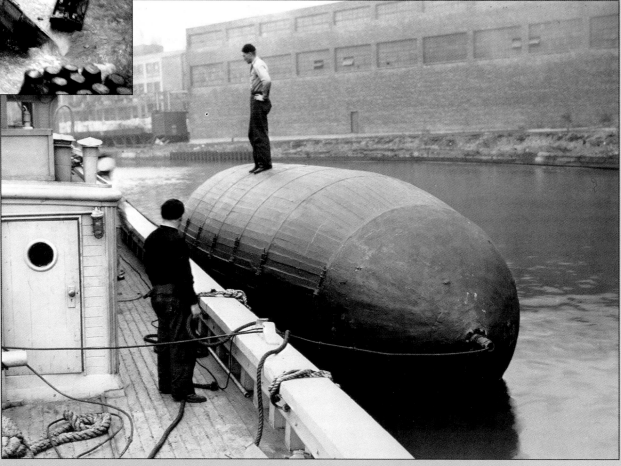

▲ The "Tym Barge" was designed as a towable, floating fuel tank for World War II ships. Designed by inventor Michael Tym, the barge was never put into use by the U.S. Armed Forces.

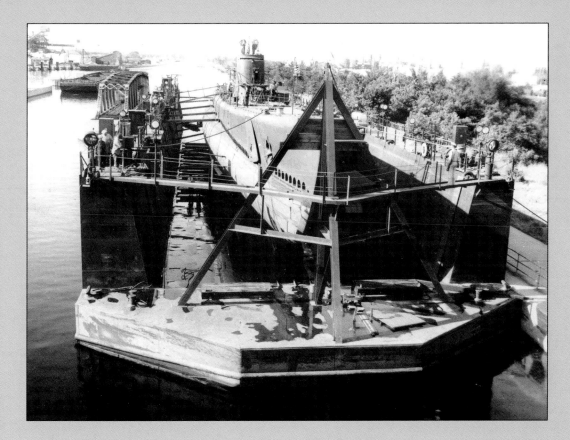

The *U.S.S. Raton*, a World War II–era submarine, in the Sanitary and Ship Canal. The submarines, constructed in Manitowoc, Wisconsin, passed through downtown Chicago on their way toward the Mississippi River and the Gulf of Mexico.

Under the Surface

During recovery efforts after the *Eastland* disaster, divers surprisingly found a small submarine at the bottom of the Chicago River. Known as the *Foolkiller*, this vessel was designed by Lodner Philips, a pioneer of early submarine design. The *Foolkiller* was removed from its muddy home on the bottom of river in 1915 and temporarily displayed for all in Chicago to see.

The *Foolkiller*, however, wasn't the only submarine to find its way into the Chicago River. A government contract during World War II ordered the construction of military submarines at the Manitowoc Shipbuilding Company in Wisconsin. The Great Lakes were protected from foreign invasion and therefore an ideal place for the construction of wartime vessels. After completion, dozens of submarines constructed at Manitowoc were transported to the open ocean through the Sanitary and Ship Canal toward the Illinois and Mississippi Rivers—a journey entirely within the protected boundaries of the United States. The passage was conducted using an adjustable floating dry dock, which permitted vessels to clear the shallow river past Lockport and pass under the many bridges that followed. The first of the many submarines to make this journey, the *U.S.S. Peto*, entered the Chicago River on December 26, 1942.

Interestingly, the Manitowoc submarines were not the only World War II–era submersibles to pass through the river. Another would make its home in the Chicago River for almost half a century. In an attempt to come up with a method for providing additional fuel to wartime vessels, inventor Michael Tym designed a 30-foot fuel tank to be towed behind warships. While the prototype worked quite well, additional Tym Barges were never ordered. The submersible was eventually docked (where it subsequently sank) near the mouth of the Chicago River. The barge was forgotten for almost 50 years but was rediscovered and towed into Lake Michigan in 1999. It remains an underwater destination for divers to this day.

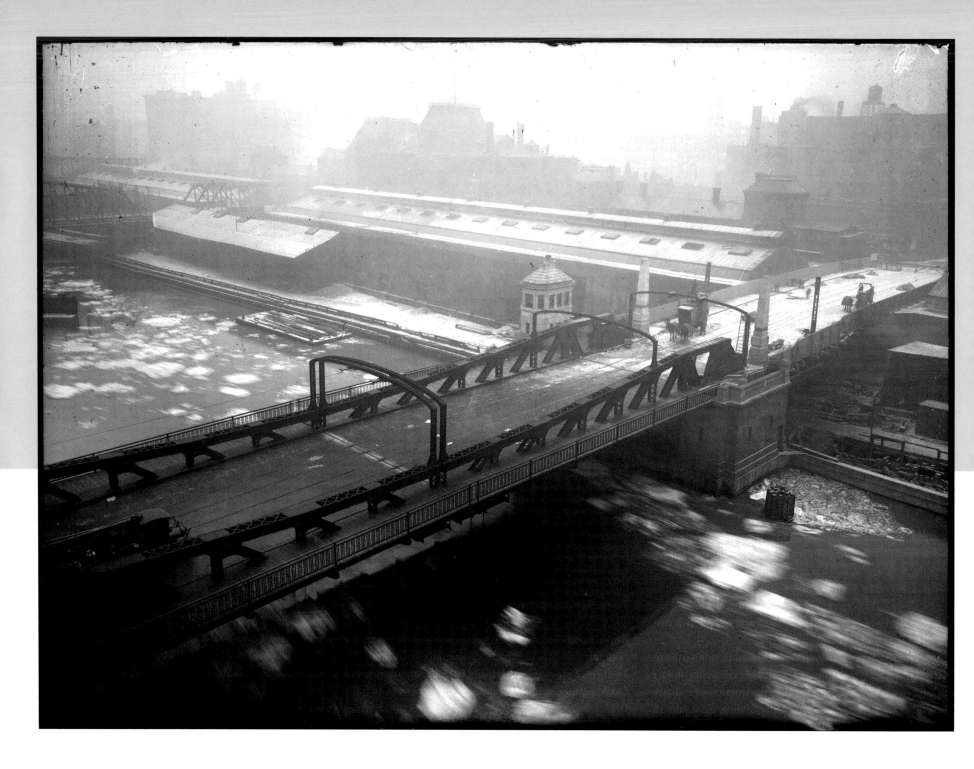

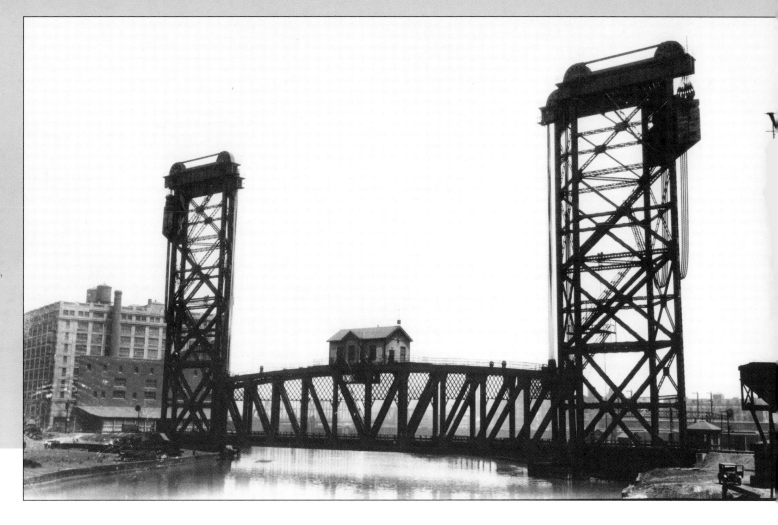

The Monroe Street Bridge, circa 1919

▶ This striking vertical lift bridge, located near Canal Street on the South Branch, is used for rail traffic. The entire span (including the control house) raises and lowers to allow for the passage of boats.

Building New Bridges

The early 20th century saw the construction of many bridges over the Chicago River, structures that were desperately needed to replace the dilapidated post-fire bridges and to accommodate further increases in downtown passenger and automotive traffic. The old center-swing bridges were removed, while numerous drawbridges and vertical lift bridges were built along the North, South, and Main Branches of the Chicago River. Perhaps the best known of these structures is the Michigan Avenue Bridge, also inspired by Daniel Burnham's 1909 *Plan of Chicago*. Constructed from 1918–1920 and designed by Edward Bennett, the Michigan Avenue Bridge is a double-leaf, double-decker trunnion bascule bridge, which permitted two levels of traffic to cross the Chicago River at the same time. The bridge towers were updated in 1928 and contain the controlling equipment used to raise and lower its gigantic spans. The bridge now serves as a vital link on Chicago's Magnificent Mile, a haven for shopping, cultural activities, and economic interests both north and south of the Chicago River. One of its towers also serves as the Friends of the Chicago River's new Bridgehouse Museum—a must-see locale for all Chicago River supporters.

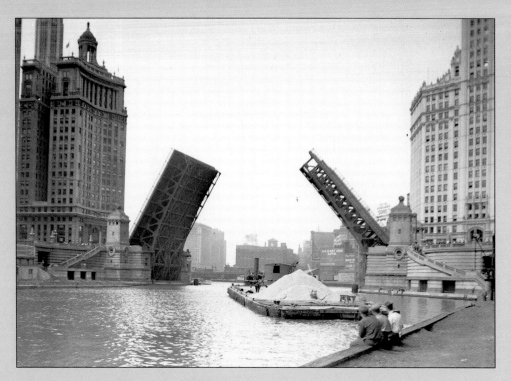

▲ The Michigan Avenue Bridge in its raised position, with a barge in the foreground, 1929.

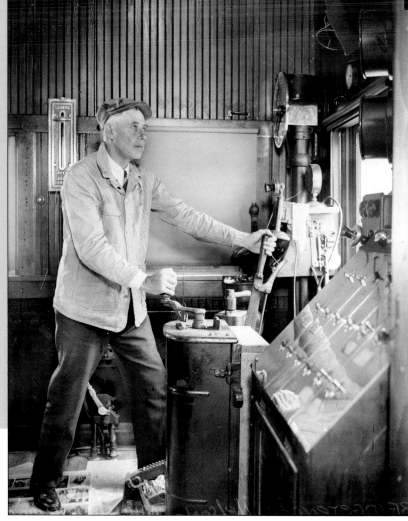

▶ A bridge tender operates the Michigan Avenue Bridge, 1929.

The Outer Drive Bridge, now known as the Lake Shore Drive Bridge, is Chicago's other double-decker trunnion bridge. It was constructed at the mouth of the Chicago River near Lake Michigan. The bridge opened to great fanfare on October 5, 1937. At the opening day festivities, President Franklin D. Roosevelt stood over the Chicago River and delivered his powerful "Quarantine Speech," arguing against the isolationist tendencies of American foreign policy in the years before World War II. Roosevelt concluded his remarks by famously declaring that "America hates war. America hopes for peace. Therefore, America actively engages in the search for peace."

▶ The construction site for the Outer Drive Bridge is visible in the middle of this 1936 photograph. The bridge was eventually renamed the Lake Shore Drive Bridge. The land near the mouth of the Chicago River was still largely industrial, and rail lines and warehouses line the water. Ogden Slip, a man-made wharf seen along the right of the photograph, is still present, although it is now significantly shorter, as the channel has been partially filled.

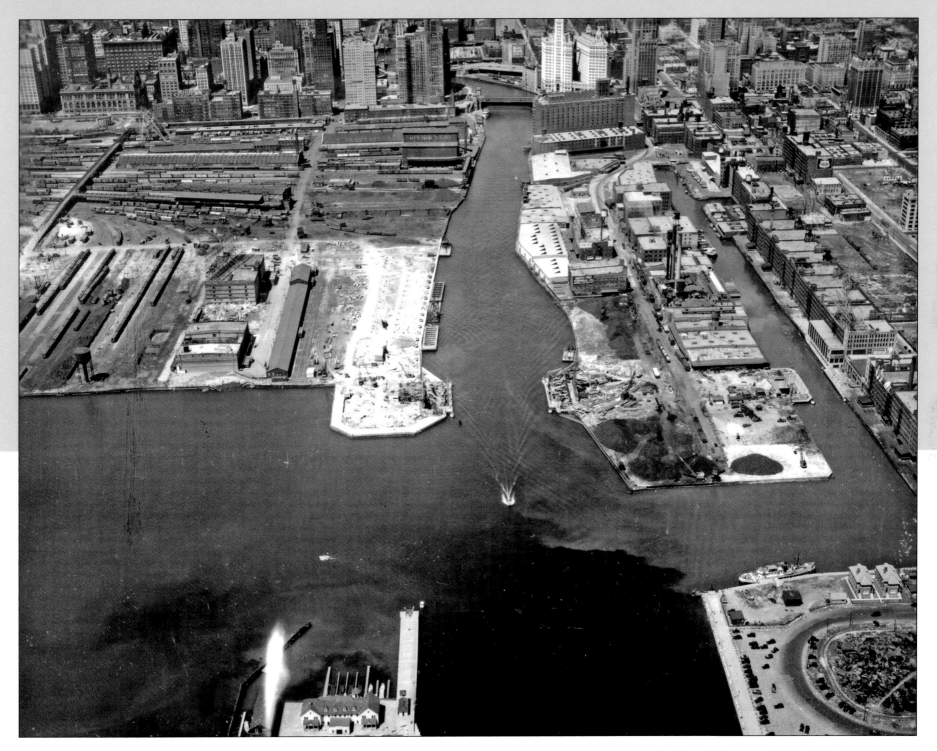

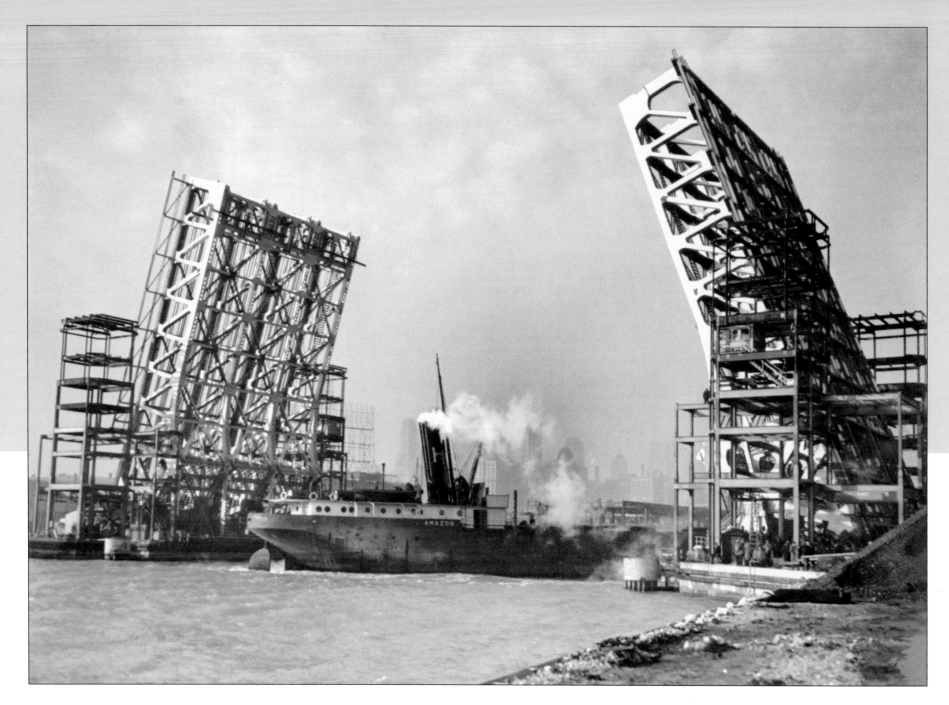

▲ Passage of the *S.S. Amazon* under the partially constructed Outer Drive Bridge. This was the bridge's first trial opening.

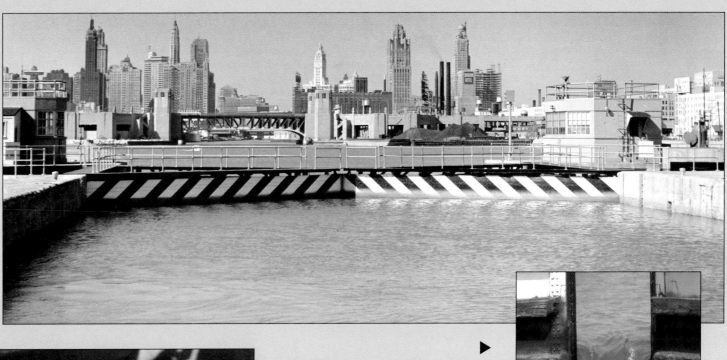

A view of the city from inside the Chicago Lock, 1961

Water from Lake Michigan pours into the Chicago River with each opening of the lock.

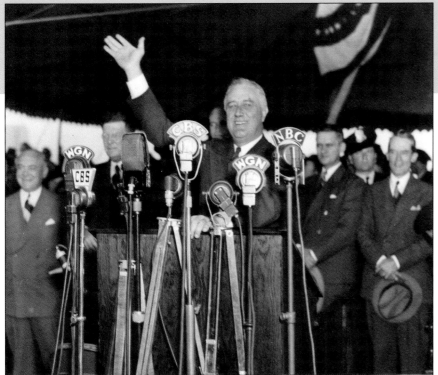

President Franklin Delano Roosevelt speaks at the opening day ceremonies of the Outer Drive Bridge.

Additional modification to the Chicago River and its harbor included the construction of the Chicago Lock. Built between 1936 and 1938 south of Municipal Pier (now Navy Pier), the Chicago Lock regulates the flow of water into the Chicago River and therefore into the Sanitary and Ship Canal. The lock also facilitates the safe entry of passenger and commercial vessels into and out of the downtown waterway. Interestingly, the first ship to pass through the newly dedicated lock on September 7, 1938, was the *U.S.S. Wilmette*, 23 years after its fateful disaster as the *S.S. Eastland*. The T.J. O'Brien Lock was constructed decades later on the Calumet River as a way to further regulate the flow of water and traffic into the Calumet, Cal-Sag, and Sanitary and Ship Canals to the south.

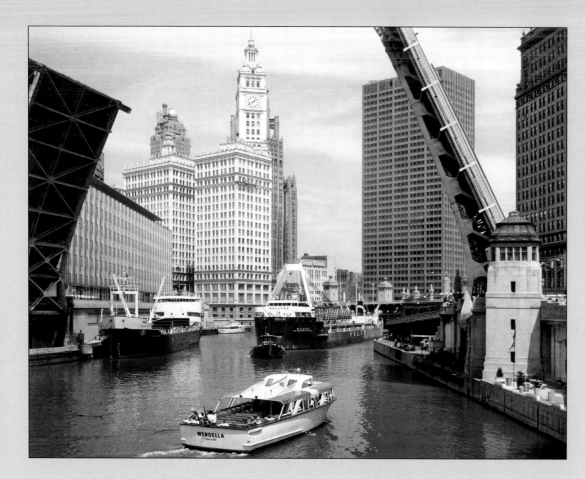

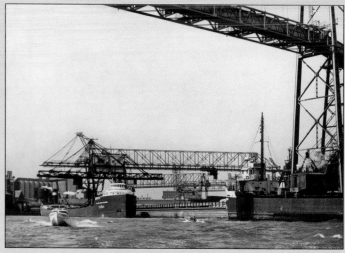

▲ Shipping in Calumet Harbor, 1961

◄

As the size of commercial vessels grew larger and industry moved southward toward the industrial ports of Illinois and Indiana, the downtown Chicago River became less advantageous for the passage of large commercial maritime vessels. Street congestion, as well as slower pedestrian traffic due to the raising and lowering of bridges, were also problems.

A Changing Riverfront

Chicago's waterways changed dramatically from the 1920s to the 1960s. Commercial maritime traffic to the downtown Chicago harbor decreased as nearby industrial harbors grew. As Great Lakes freighters became bigger, the harbors at Calumet and Gary proved better for vessel dockage and unloading than the narrower Chicago River. Combined with a large increase in the amount of goods transported through the Illinois River system, as well as the growth of heavy industry in Indiana, the surrounding harbors were better able to compete for expanding national and international freight. The opening of the St. Lawrence Seaway in 1959 meant that vessels on the Great Lakes could grow to the size of ocean liners, clearly too large for downtown Chicago and its low-lying drawbridges. The harbors at Gary and Calumet became all the more attractive.

Meanwhile, significant advances in architectural design and construction techniques meant that the warehouses, stores, and wharves that once lined the downtown Chicago River were rapidly being replaced by modern skyscrapers. Chicago was now growing upward as well as outward. In the 1920s and 1930s, landmarks such as the London Guarantee Building, the Wrigley Building, the Tribune Tower, the Merchandise Mart, and the Jewelers, Civic Opera, and Daily News Buildings boldly set new standards for riverfront architecture. The placement of Wacker Drive along the river's edge in 1926 redefined how Chicago would approach its river. Later waves of construction in the 1950s and 1960s, including the Sun-Times Building and the river-friendly Marina City, further sculpted the look of Chicago's skyline as well as its riverfront identity.

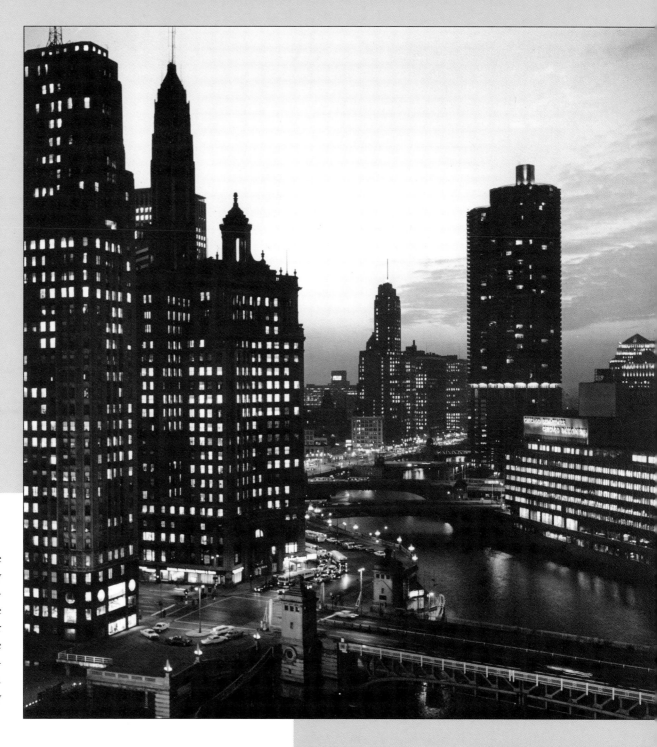

This 1960s evening riverscape demonstrates a growing focus on architecture along the Chicago River. Wacker Drive lines the southern bank of the Main Branch. The former Chicago Sun-Times building can be seen to the right. The property was demolished in 2004 to make room for further development along the river.

A peculiar tradition also started around this time, one that's brought the humble Chicago River more notoriety than any of its public works projects. Under the administration of legendary mayor Richard J. Daley, a large amount of green dye was dumped into the Chicago River on St. Patrick's Day in 1962. This now annual occurrence (and its wildly popular parade) attracts hundreds of thousands of cheering revelers to the Chicago River each year. While one might argue that the river does not need any additional pollution, the dye, at least, is biodegradable.

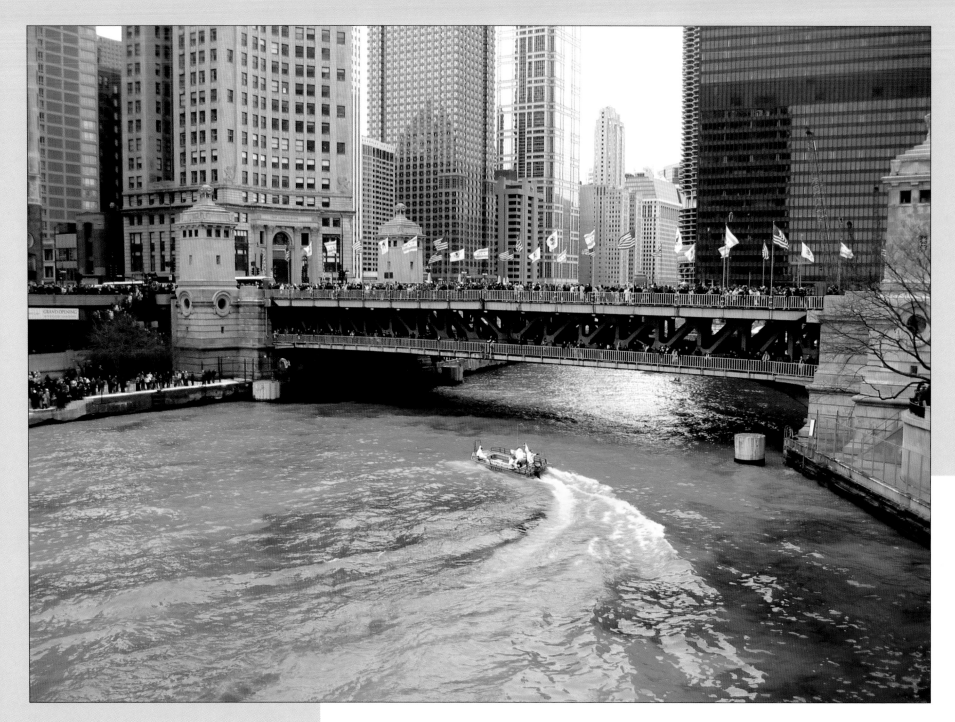

▲ The Chicago River dyed green on St. Patrick's Day

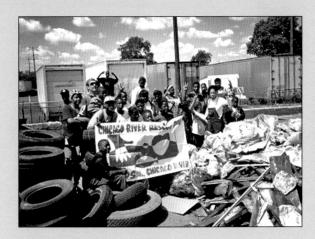

▲ Children who volunteered during the Friends of the Chicago River's annual River Rescue Day help to demonstrate how we can all help to clean up the waterway and its shoreline.

▶

The Flatwater Classic, an annual canoe and kayak race, encourages hundreds of people every year to explore Chicago on the river.

Significant effort, however, is being devoted toward changing this. At the Friends of the Chicago River's 2003 Chicago River Summit, Illinois Lieutenant Governor Pat Quinn, as chairperson of the Illinois River Coordinating Council and summit co-sponsor, announced an ambitious goal of making the Chicago River "swimmable and fishable" by 2020. The Illinois Environmental Protection Agency has also been analyzing the entire waterway to help guide the state in applying Clean Water Act requirements. A Chicago River Corridor Development Plan was developed as a preliminary guideline for the "revitalization of the Chicago River." Chicago mayor Richard M. Daley,

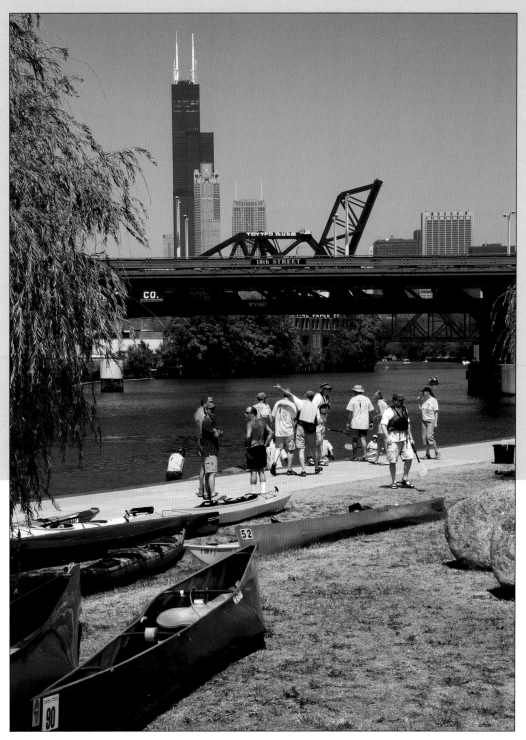

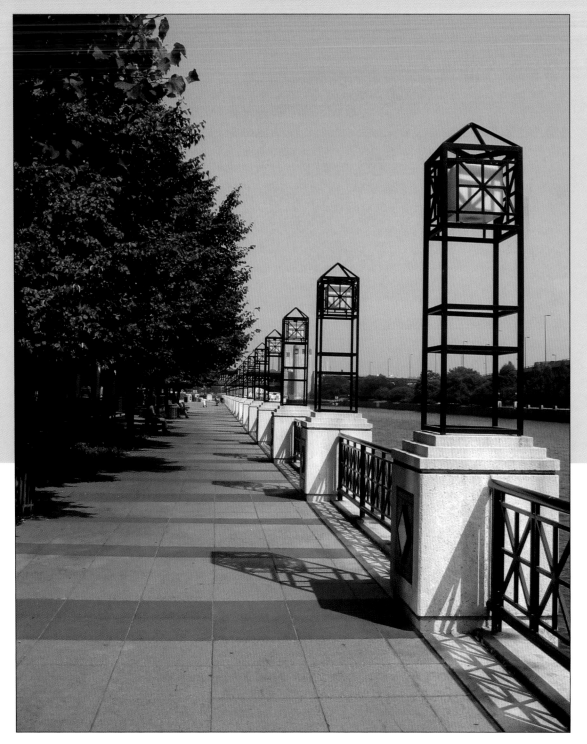

◄

Riverwalk along the Main Branch

who is a longtime advocate of Chicago River improvement, announced another visionary program, the Chicago River Agenda. The goal of this program is to develop and preserve more parkland along the water's edge, help restore its riverbanks, create a trail along the entire stretch of the waterway, and continue to make improvements in sewer outflow, water quality, and public access to the river.

In fact, improvements are already well underway. The MWRD-constructed Sidestream Elevated Pool Aeration (SEPA) project has facilitated the chemical-free aeration of water at five sites along the Chicago River. Newer proposals, like a man-made wetlands filtration project, may one day further improve the quality of the water released

▲ The river's edge near Erie Street on the North Branch

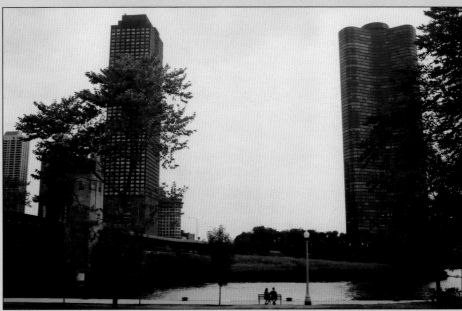

▲ A couple sits on the south bank of the Main Branch looking toward the future home of DuSable Park. Lake Shore Drive can be seen on the left side of the photograph. Lake Point Tower (right) and the North Pier Apartments (left) are also visible in the background.

into the river. Additional funding for watershed planning should help to reduce pollution by industrial chemicals and runoff from streets and sewers.

Other improvements will be much more visible, such as the development of new parklands. One such location, DuSable Park, is a small plot of land in the heart of downtown Chicago near Lake Shore Drive. DuSable Park pays homage to Chicago's founders and the role that the Chicago River played in the formation of this great city. Another, Erie Park on the North Branch, provides Chicagoans with a relaxing vista in the nearby north business community. Located on the South Branch, Ping Tom Park offers a unique flair to the Chinatown neighborhood. With an

ever-increasing desire for outdoor dining facilities and cafés along the waterway, open spaces to relax and play, and scenic vistas of the city, residents and visitors to Chicago will one day find even more ways to enjoy the unique architecture and environment attainable only along the river's edge. Thanks to the hard work of volunteers and the commitment of Chicago's civic leaders and business community, as well as an increased public awareness, the Chicago River is becoming a great symbol of pride for the city and residents of Chicago.

▼ A glorius sunset from the Chicago River

▲ Ping Tom Park on the South Branch

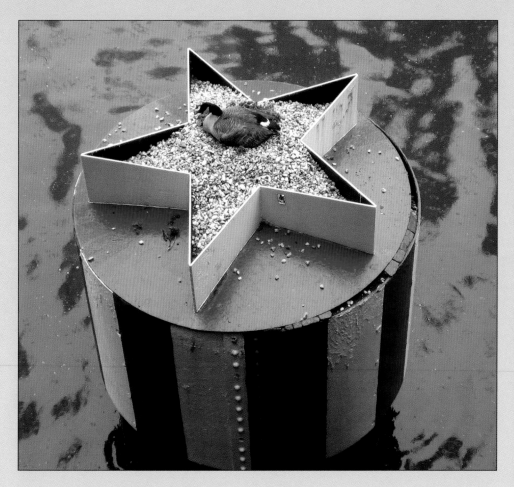

▲ A goose watches her nest on top of a Chicago River piling.

Life Returns to the Water

The Chicago River is once again finding itself home to many species of birds, some of which can be found in rather surprising places. Canada geese, ducks, herons, and egrets are now quite common, even in Bubbly Creek. The entire North Branch has become a bird-watcher's paradise due to increased riverside vegetation and a decrease in the commercial traffic along the waterway.

▶

Mallard ducks swimming in the Main Branch

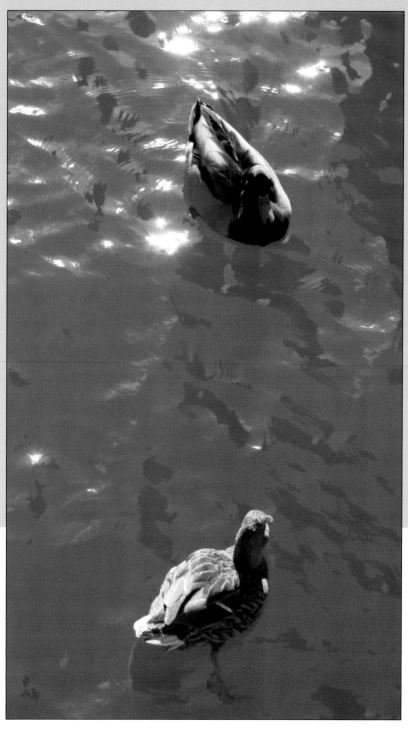

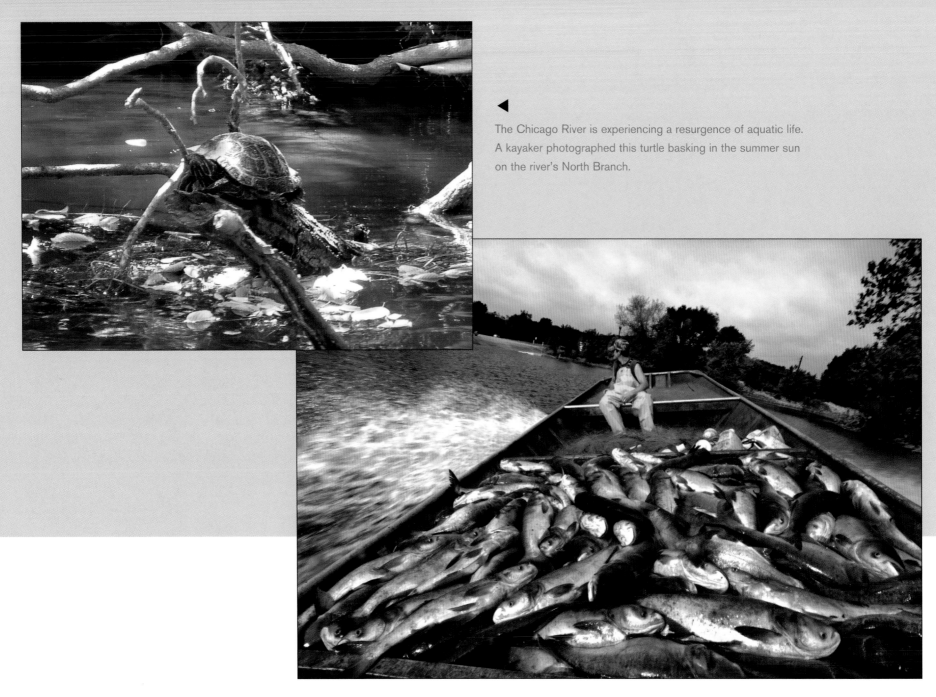

The Chicago River is experiencing a resurgence of aquatic life. A kayaker photographed this turtle basking in the summer sun on the river's North Branch.

▲ A boat filled with Asian carp caught on the Illinois River

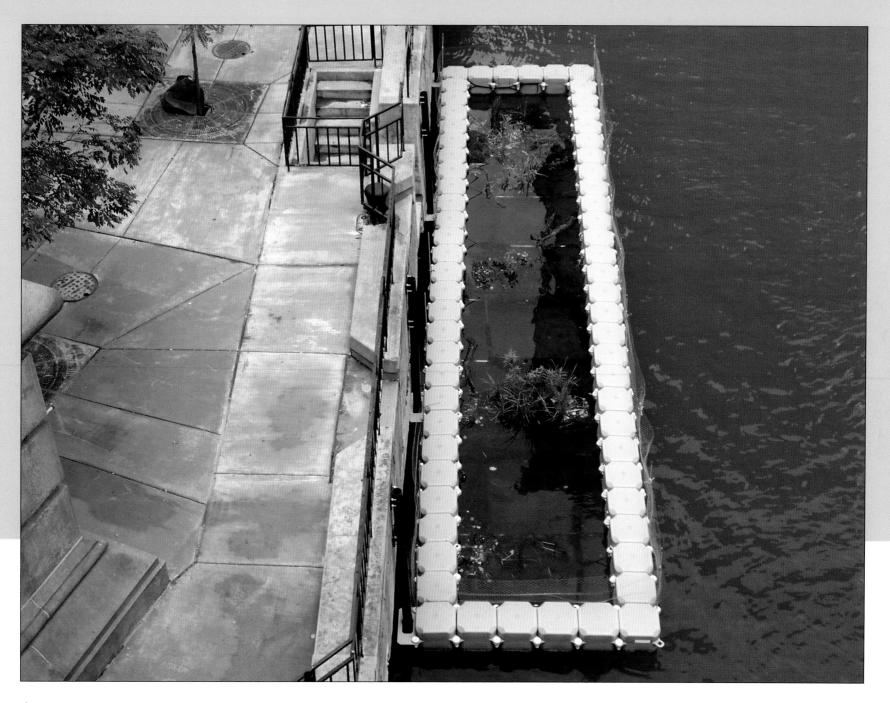

▲ Friends of the Chicago River constructed a "fish hotel" near the Michigan Avenue Bridge in order to promote an enhanced ecosystem for aquatic life in the river.

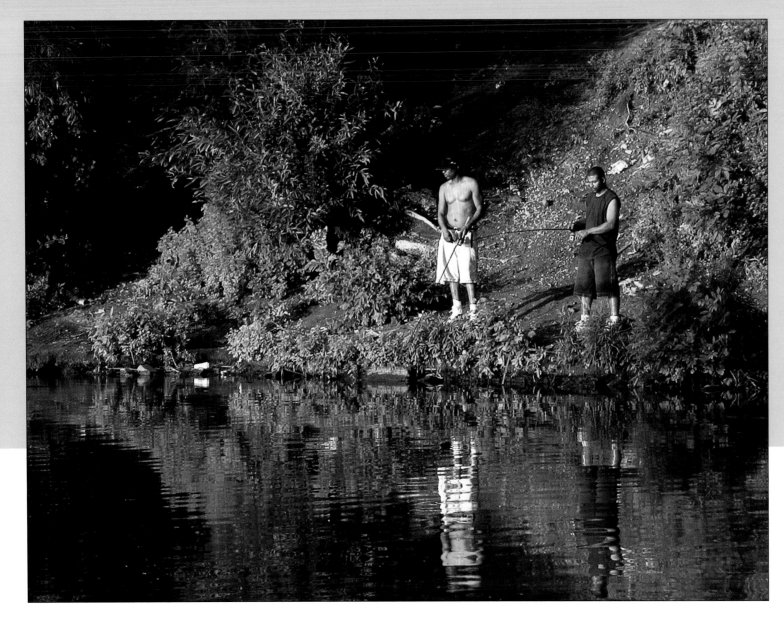

Amazingly, the Chicago River now supports more than 60 species of fish as well. Bass, pike, trout, and bluegill are all found in its waters. As proof of this rebound of aquatic life, national fishing tournaments have recently been hosted along the river, something that would've been unthinkable just decades ago. The Illinois Department of Public Health, however, publishes annual guidelines regarding what species and sizes of fish are safe to consume.

Birds and fish are not the only animals to make the river home. Numerous mammals can also be spotted along the river's edge, such as beavers, muskrats, foxes, and raccoons, all of which find refuge and food along the banks of the Chicago River. Turtles and frogs also call the river home, and the recent discovery of breeding mussels in the North Branch suggests that the environmental health of the river continues to improve.

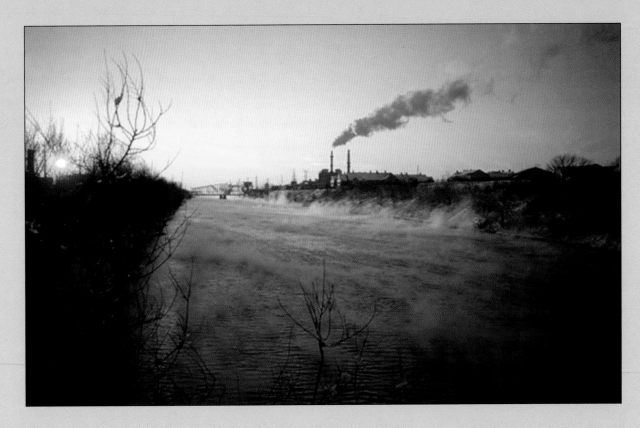

◀
A wintertime view of the Sanitary and Ship Canal

An Immediate and Persistent Threat

Improvements in water quality have presented an interesting conundrum. As a consequence of renewed life in the river, the threat of invasion by unwanted aquatic species into the Chicago River and Lake Michigan ecosystems has increased. A recent meeting of scientists and policy makers described this possibility as "the most urgent environmental threat to the Great Lakes and Mississippi River Basin." More than 100 "nuisance species" (those not indigenous to local waterways) have been identified in the Great Lakes. Zebra mussels are probably the best-known example of an aquatic species introduced to the area, in this case by the release of ballast water from ships.

Completely consistent with its purpose, the Sanitary and Ship Canal directly connected the Great Lakes with the Illinois and Mississippi River systems. In doing so, it secondarily created an "aquatic highway" for these species to wreak havoc on the natural environment. Improved water quality in the Chicago River unfortunately increases the possibility of such a scenario occurring, as the nuisance species have a much greater possibility of surviving this complicated journey.

The Sanitary and Ship Canal was thus the perfect location for a novel "fish barrier" to help prevent the spread of nuisance species into and out of the Chicago River and

Lake Michigan. Electrical barriers, underwater electric fields designed to repel fish (but not electrocute humans) have now been installed on the canal in Romeoville. It is hoped that this barrier will deter the spread of species such as the Asian carp northward toward Lake Michigan and slow the spread of the round goby toward the Mississippi River fisheries. Asian carp can destroy native habitat by overfeeding (often growing larger than 100 pounds) and are prolific breeders, making it imperative that this and other species are prevented from making their way through the canal. Many of these invasive species also prey on native aquatic life as well.

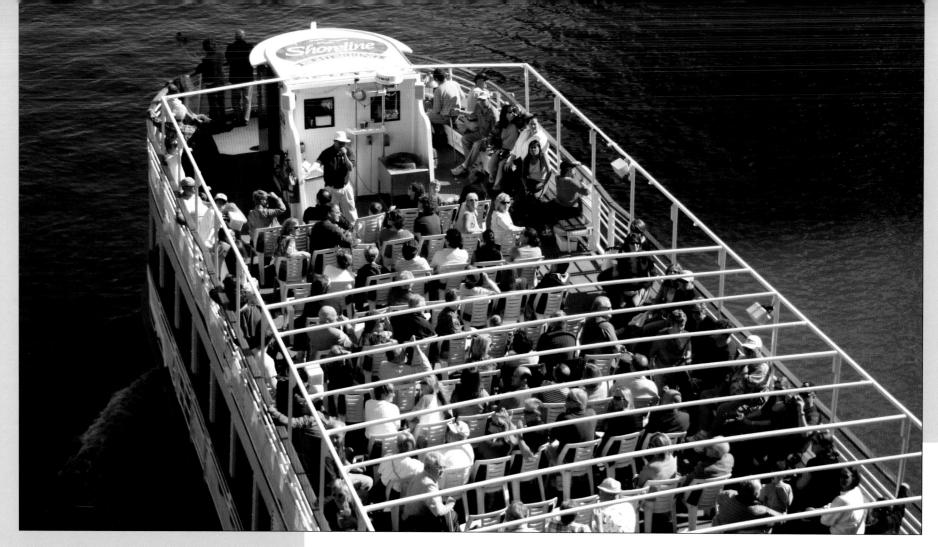

▲ A popular architectural tour boat carries passengers on a fascinating round-trip river journey through Chicago's downtown.

People on the Water

Along with an increase in aquatic life, humans can also be found enjoying the water of the Chicago River. Recreational, educational, and architectural river tours regularly take thousands of Chicagoans and tourists on trips through the downtown waterway, teaching them about Chicago's history and the amazing story of its river. Others prefer to paddle or row through the Chicago River's urban and natural environment. Regattas bring world-class rowers to the downtown community. Organizations like the Chicago River Rowing and Paddling Center, Chicago River Canoe and Kayak, the Chicagoland Canoe Base, and the Lincoln Park Boat Club enable visitors to explore the Chicago River in the same manner that Joliet and Marquette did hundreds of years before. The Ralph C. Frese Canoe Trail, named after Chicago's notable canoe enthusiast and conservationist, is an example of a truly wonderful paddle trip that extends along the North Branch of the Chicago River. Others choose to enjoy the I&M Canal National Heritage Corridor, where

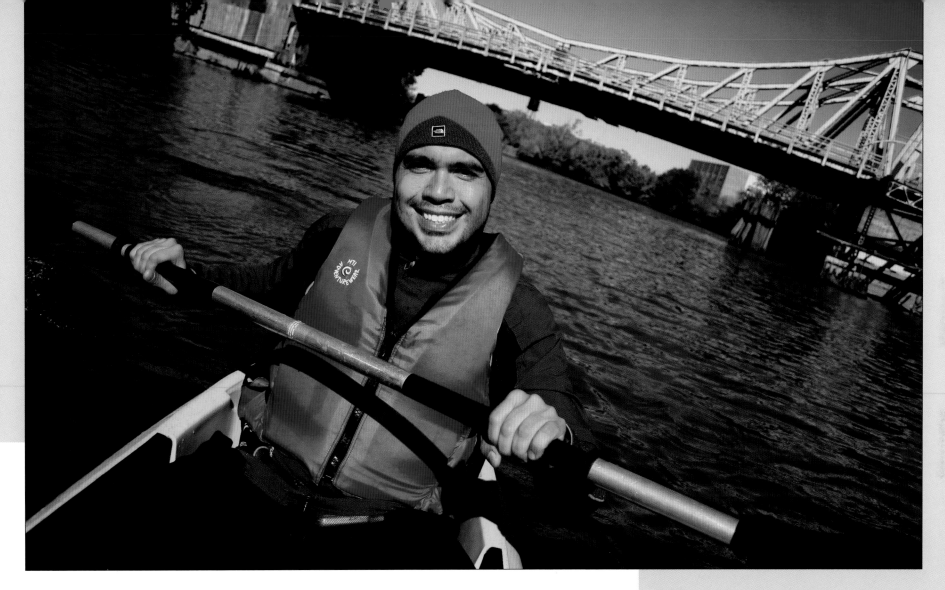

you can drive, bike, walk, cross-country ski, or even paddle your way through what remains of the historic canal and its surrounding towns.

A collaboration among the Illinois Paddling Council, the Illinois Department of Natural Resources, and the Openlands Project led to the development of the Northeastern Illinois Regional Water Trails Plan, with a goal of providing access to paddlers along the entire waterfront in the Chicagoland area. There are now actually more than 100,000 boaters in the region, and hundreds of power-boats and sailboats can be seen passing through the Chicago River on their way to Lake Michigan. Expansion in urban renewal and the growing interest in healthy outdoor life-styles indicates that these numbers will only continue to increase as more people recognize the natural beauty and recreational rewards of the Chicago River.

▲ Kayaks and canoes are frequent sights along the entire Chicago River system.

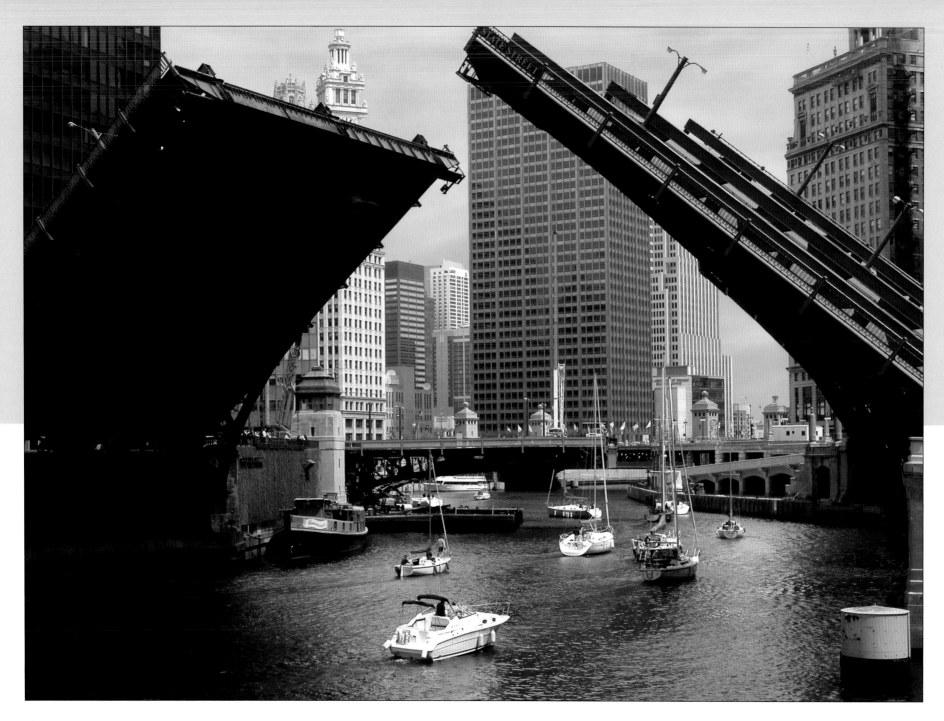

▲ Groups of sailboats leaving the Chicago River for the harbors of the Lake Michigan shoreline. City workers must open the bridges to allow the passage of boats.

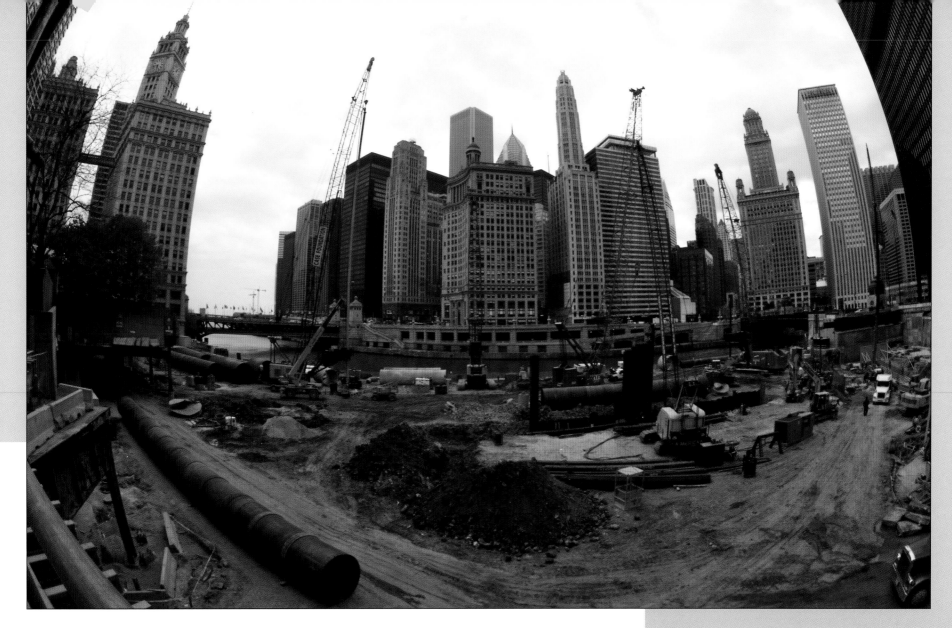

Chicago's Second Shoreline

The aesthetic renewal of the Chicago River has made it a desirable place to live and work near. Elegant buildings such as Lake Point Tower, 333 West Wacker, River City, and the R.R. Donnelley Center approach and reflect the water in their construction. A boom in residential develop-ment along the Main Branch and Bubbly Creek speak to a change in overall perspective on the waterway. Continued improvements along the Riverwalk and a tradition of for-ward-thinking metropolitan design suggest that even more exciting changes to this city and its riverfront await us.

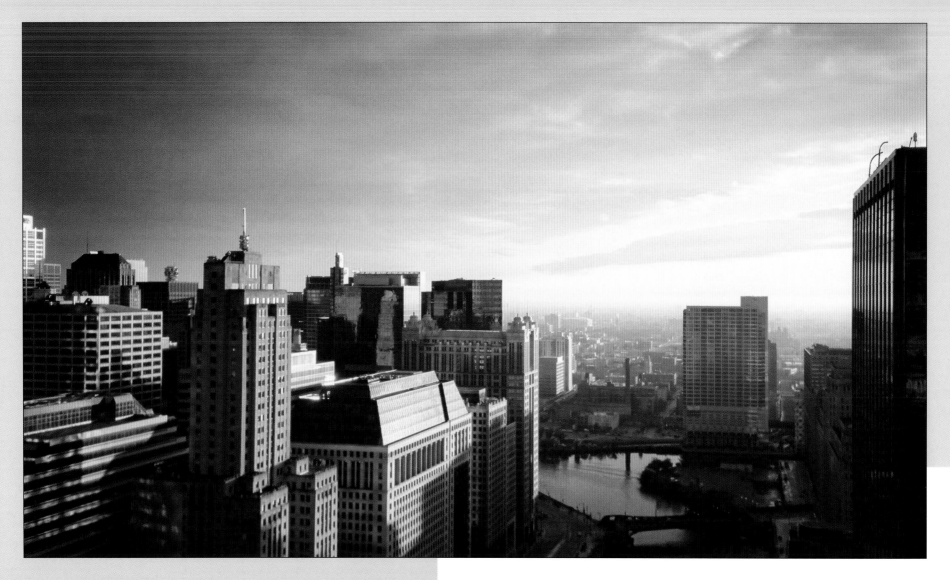

▲ The view toward present-day Wolf Point from Marina City

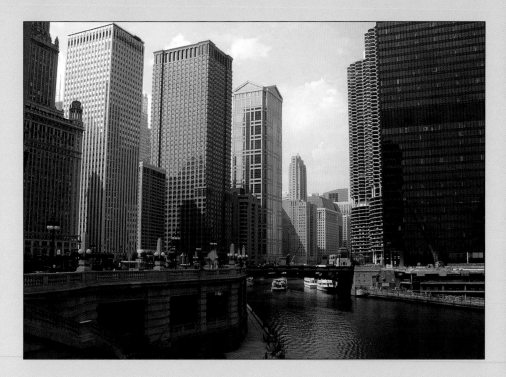

▲ The view along the Main Branch reveals a magnificent contrast between modern and classical architectural styles.

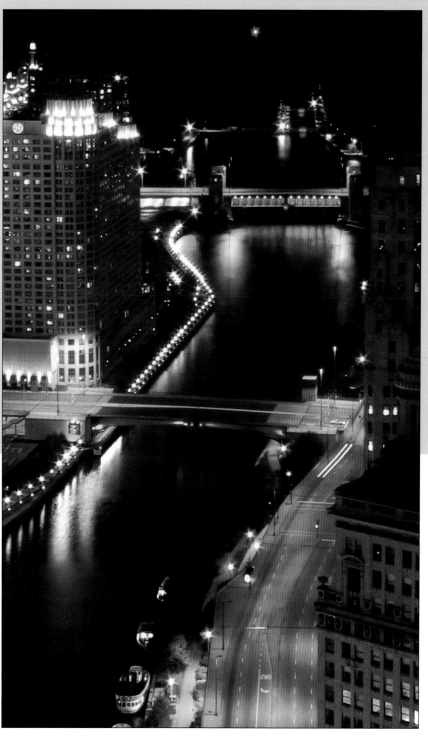

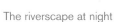

The riverscape at night

Final Thoughts

Journeying through the Main Branch of the Chicago River by water, or simply observing downtown Chicago at night from one of the many bridges that cross its banks, inspires not just awe, but also a profound appreciation for the history of Chicago and the constant struggle and ingenuity that it took to build it. The Chicago River has been pushed to unthinkable extremes in an effort to support the needs of our expanding metropolis. We have slowly been forced to acknowledge that Chicago's evolving future is also intertwined with the future of its river.

◀

An evening architectural cruise on the Chicago River

If we continue to invest in newer technologies in sewage treatment, conserve and expand the river's remaining natural habitats, focus on decreasing urban and industrial pollution, and enhance the recreational and aesthetic interface along its banks, the relationship between this city and this river will continue to blossom. The Chicago River is a waterway unlike any other, as dynamic as the city whose destiny it shares.

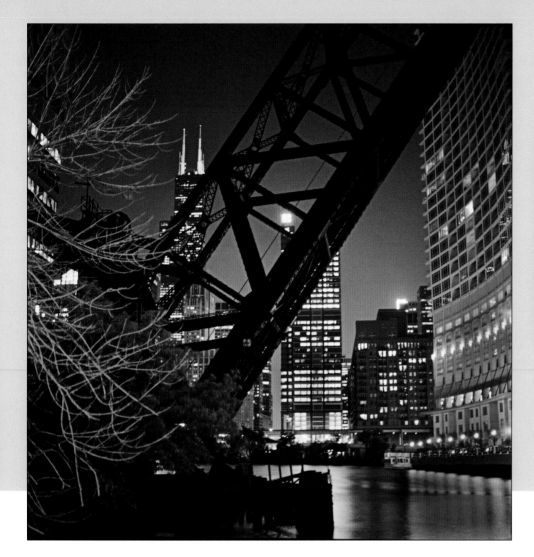

▲ A view from the North Branch looking downtown

▲ Sunset on the Chicago River

Photography Credits

Front Cover Wei-Peng Yong

p. 2 Gavin Hesketh, 2005

p. 4 Courtesy of Chicago History Museum (ICHI-39434)

Beginnings: The Bedrock of Chicago

p. 6 [bottom] Jonathan Genzen, 2005

p. 7 Illinois State Geographical Survey map *Quaternary Deposits of Illinois* (1996)

p. 8 Adapted from *The Chicago River From Your Window: An Illustrated River Watcher's Guide* by Paul Frisbie. Friends of the Chicago River: Chicago, 2002. Used with permission.

p. 9 *Chicago Daily News* image courtesy of Chicago History Museum (DN-0001982)

A Sluggish River in the Great Frontier (1600–1800)

p. 11 Courtesy of the Gerald Peters Gallery

p. 12 [left] Courtesy of Chicago History Museum (ICHI-10889)

p. 12 [right] Courtesy of Chicago History Museum (ICHI-39427)

p. 13 Courtesy of Chicago History Museum (ICHI-39430)

p. 14 *History of Chicago: From the Earliest Period to the Present Time*, A.T. Andreas, Chicago, 1884

p. 15 Raoul Varin. Courtesy of Chicago History Museum (ICHI-05623 c.1928)

p. 16 Raoul Varin. Courtesy of Chicago History Museum (ICHI-39438 c.1926-1932)

p. 17 *Chicago Daily News* image courtesy of Chicago History Museum (DN-0009354)

Chicago Rises Along the Riverbanks (1800–1900)

p. 18 [bottom] *Chicago Daily News* image courtesy of Chicago History Museum (DN-0058274)

p. 19 Raoul Varin, circa 1928. Courtesy of Chicago History Museum (ICHI-39439)

p. 20 Courtesy of Chicago History Museum (ICHI-05768)

p. 21 [top left] *History of Chicago: From the Earliest Period to the Present Time*, A.T. Andreas, Chicago, 1884

p. 21 [bottom right] *History of Chicago: From the Earliest Period to the Present Time*, A.T. Andreas, Chicago, 1884

p. 22 *History of Chicago: From the Earliest Period to the Present Time*, A.T. Andreas, Chicago, 1884

p. 23 Courtesy of Chicago History Museum (ICHI-00466)

p. 24 [left] 49th U.S. Congress, 2nd Session, Ex.79

p. 24 [right] Courtesy of Chicago History Museum (ICHI-14151). Not for legal tender.

p. 25 Courtesy of Chicago History Museum (ICHI-39426)

p. 26 [left] Library of Congress, Rare Book and Special Collections Division, Alfred Whital Stern Collection of Lincolniana

p. 26 [right] *History of Chicago: From the Earliest Period to the Present Time*, A.T. Andreas, Chicago, 1884

p. 27 Robert N. Dennis Collection of Stereoscopic Views, Miriam and Ira D. Wallach Division of Art, Prints and Photographs, The New York Public Library, Astor, Lenox, and Tilden Foundations

p. 28 Robert N. Dennis Collection of Stereoscopic Views, Miriam and Ira D. Wallach Division of Art, Prints and Photographs, The New York Public Library, Astor, Lenox, and Tilden Foundations

p. 29 *Chicago Daily News* image courtesy of Chicago History Museum (DN-0003433)

p. 30 Raoul Varin. 1928. Courtesy of Chicago History Museum (ICHI-39440)

p. 31 Courtesy of Chicago History Museum (ICHI-39432)

p. 32 H.M. Kinsley, after a painting by L.V.H. Crosby. Courtesy of Chicago History Museum (ICHI-02949)

p. 33 Courtesy of Chicago History Museum (ICHI-02953)

p. 34 Courtesy of Chicago History Museum (ICHI-02957)

p. 35 Courtesy of Chicago History Museum (ICHI-14894)

p. 36 Courtesy of Chicago History Museum (ICHI-02811)

p. 37 [top right] Jex Bardwell, photographer. Courtesy of Chicago History Museum (ICHI-20596)

p. 37 [bottom right] Courtesy of Chicago History Museum (ICHI-03762)

p. 38 Courtesy of Chicago History Museum (ICHI-31289)

p. 39 Courtesy of Chicago History Museum (ICHI-39423)

p. 40 Courtesy of Chicago History Museum (ICHI-39425)

p. 41 [top] Courtesy of John Crerar Library, University of Chicago

p. 41 [bottom left] *Chicago Daily News* image courtesy of Chicago History Museum (DN-0063478)

p. 41 [bottom right] Courtesy of Chicago History Museum (ICHI-39424)

p. 42 Courtesy of Chicago History Museum (ICHI-05853)

p. 43 Courtesy of Chicago History Museum (ICHI-14876)

p. 44 [top left] *Chicago Daily News* image courtesy of Chicago History Museum (DN-0054509)

p. 44 [bottom right] *Chicago Daily News* image courtesy of Chicago History Museum (DN-0063511)

p. 45 Courtesy of Chicago History Museum (ICHI-05775)

An Industrial Waterway in the Second City (1900–2000)

p. 47 [top left] *Chicago Daily News* image courtesy of Chicago History Museum (DN-0077911)

p. 47 [bottom left] *Chicago Daily News* image courtesy of Chicago History Museum (DN-0009001)

p. 47 [right] *Chicago Daily News* image courtesy of Chicago History Museum (DN-0056256)

p. 48, 49 George Lawrence, photographer. Courtesy of Chicago History Museum (ICHI-04081)

p. 50 *Chicago Daily News* image courtesy of Chicago History Museum (DN-0056839)

p. 51 [left] *Chicago Daily News* image courtesy of Chicago History Museum (DN-0001981)

p. 51 [right] Courtesy of Chicago History Museum (ICHI-39428)

p. 52 [top] *Chicago Daily News* image courtesy of Chicago History Museum (DN-055684)

p. 52 [bottom left] *Chicago Daily News* image courtesy of Chicago History Museum (DN-0064352)

p. 52 [bottom right] Liberty Numismatics. Collection of the author

p. 53 *Chicago Daily News* image courtesy of Chicago History Museum (DN-066835)

p. 54 Courtesy of Chicago History Museum (ICHI-30786)

p. 55 [left] Jun Fujita, photographer. Courtesy of Chicago History Museum (ICHI-30783)

p. 55 [right] *Chicago Daily News* image courtesy of Chicago History Museum (DN-0064947)

p. 56 [top left] *Chicago Daily News* image courtesy of Chicago History Museum (DN-0065015)

p. 56 [bottom left] *Chicago Daily News* image courtesy of Chicago History Museum (DN-0065178)

p. 56 [right] *Chicago Daily News* image courtesy of Chicago History Museum (DN-0064951)

p. 57 Jun Fujita, photographer. Courtesy of Chicago History Museum (ICHI-30729)

p. 58 *Chicago Daily News* image courtesy of Chicago History Museum (DN-0065024)

p. 59 *Chicago Daily News* image courtesy of Chicago History Museum (DN-0088510)

p. 60 [left] *Chicago Daily News* image courtesy of Chicago History Museum (DN-0065730)

p. 60 [right] The family of Michael Tym

p. 61 Wisconsin Maritime Museum Collection

p. 62 *Chicago Daily News* image courtesy of Chicago History Museum (DN-0009856)

p. 63 Chicago History Museum ICHI-39429.

p. 64 [left] *Chicago Daily News* image courtesy of Chicago History Museum (DN-0089208)

p. 64 [right] *Chicago Daily News* image courtesy of Chicago History Museum (DN-0089206)

p. 65 Courtesy of Chicago History Museum (ICHI-20308)

p. 66 Courtesy of Chicago History Museum (ICHI-16214)

p. 67 [bottom left] As published in the *Chicago Daily Times*. © 1937 by *Chicago Sun-Times*, Inc. Reprinted with permission.

p. 67 [top right] Raymond F. Stibal, photographer. Courtesy of Chicago History Museum (ICHI-37411)

p. 67 [middle right] Bonnie Underwood, 2005

p. 68 [left] Courtesy of Chicago History Museum (ICHI-39433)

p. 68 [right] Robert Foote, photographer. Courtesy of Chicago History Museum (ICHI-39431)

p. 69 Courtesy of Chicago History Museum (ICHI-39434)

p. 70 Bradley M. Froehle, 2005

p. 71 [top left] © MWRDGC2002-7

p. 71 [bottom left] © MWRDGC2002-7

p. 71 [right] © MWRDGC2002-7

p. 72 [p.1 left] Denise Foy, 2005

p. 73 [left] © MWRDGC2002-7

p. 73 [right] Courtesy of Chicago History Museum (ICHI-39437)

A River's Revival (2000 and Beyond)

p. 75 [left] Courtesy of David Solzman, photographer

p. 75 [right] Courtesy of David Solzman, photographer

p. 76 [left] Kevin Zolkiewicz, 2005

p. 77 [left] Courtesy of David Solzman, photographer

p. 77 [right] Jonathan Genzen, 2002

p. 78 [left] Michael Meiser, 2004

p. 78 [right] Wei-Peng Yong

p. 79 [left] Kathryn Fitzgerald, 2005

p. 79 [right] Denise Foy, 2005

p. 80 [left] Brian McCoy, 2005

p. 80 [right] Marlin Levison, photographer. © 2006, *Star Tribune*/Minneapolis-St. Paul

p. 81 Tony Dornacher, 2005

p. 82 Courtesy of David Solzman, photographer

p. 83 Courtesy of David Solzman, photographer

p. 84 Denise Foy, 2005

p. 85 [p.1 right] Denise Foy, 2005

p. 86 © 2006 by Art Hill

p. 87 Pete Baker, 2005. www.treemeat.com

p. 88 Tamsin Edwards, 2004

p. 89 [left] Paul W. Puckett, Jacksonville, Florida, 2005

p. 89 [right] Gavin Hesketh, 2005

p. 90 Sherwin Techico, 2005

p. 91 [left] Chris Anderson, 2005

p. 91 [right] Marilyn Audsley, 2004

p. 96 Jennifer T. Gosselin, 2006

Back Cover Raoul Varin. 1928. Courtesy of Chicago History Museum (ICHI-39440)

Bibliography

General History

Andreas, Alfred T. *History of Chicago: From the Earliest Period to the Present Time*. Vols. 1–3. Chicago: A.T. Andreas, 1884.

Hansen, Harry. *The Chicago*. New York: Farrar & Rinehart, Inc., 1942.

Hill, Libby. *The Chicago River: A Natural and Unnatural History*. Chicago: Lake Claremont Press, 2000.

Illinois Department of Natural Resources. *Chicago River/Lake Shore Area Assessment*. Office of Scientific Research and Analysis. Champaign, Ill., 2001.

Lindsay, Joan V. *Chicago From the River*. Northfield, Ill., 2005.

Mayer, Harold M. *Chicago: Growth of a Metropolis*. Chicago: University of Chicago Press, 1969.

Mayer, Harold M. and Richard C. Wade. *The Port of Chicago and the St. Lawrence Seaway*. Chicago: University of Chicago Press, 1957.

Moffat, Bruce. *Forty Feet Below: The Story of Chicago's Freight Tunnels*. Glendale, Ca.: Interurban Press, 1982.

Nelson, William T. (Rear Admiral U.S.N., Ret.). *Fresh Water Submarines: The Manitowoc Story*. Manitowoc, Wis.: Hoeffner Printing, 1986.

Solzman, David M. *The Chicago River: An Illustrated History and Guide to the River and Its Waterways*. Chicago: University of Chicago Press, 2006.

Staff of the *Chicago Tribune*. *Chicago Days: 150 Defining Moments in the Life of a Great City*. Edited by Stevenson Swanson. Wheaton, Ill.: Cantigny First Division Foundation, 1997.

Trigger, Bruce G. *Handbook of North American Indians*. Edited by William C. Sturtevant. Washington, D.C.: Smithsonian Institution, 1978.

Exploration, Settlement, and Early Chicago

Danckers, Ulrich, and Jane Meredith. *A Compendium of the Early History of Chicago to the Year 1835 When the Indians Left*. River Forest, Ill.: Early Chicago, Inc., 1999.

Delanglez, Jean. *Life and Voyages of Louis Jolliet*. Chicago: Institute of Jesuit History Publications, 1948.

Derome, Robert. "John Kinzie Silversmith (1763-1828): His Early Career as Shawneeawkee 'The Silver Man.'" www.er.uqam.ca/nobel/r14310/Kinzie/

Donnelly, Joseph P. *Jacques Marquette*. Chicago: Loyola University Press, 1968.

Kinzie, Juliette H., and Linai Helm. "The Fort Dearborn Massacre: 'Waubun,' 1812." www.hillsdale.edu/Personal/Stewart/war/America/1812/ North/1812-Dearborn-Kinzie.htm

Eastland Disaster

Bonansinga, Jay. *The Sinking of the Eastland: America's Forgotten Tragedy*. New York: Citadel Press, 2004

Eastland Disaster Historical Society. "Eastland Disaster Historical Society: History of a Chicago & Great Lakes Steamliner Shipwreck." www.eastlanddisaster.org

Eastland Memorial Society. www.eastlandmemorial.org

Hilton, George W. *Eastland: Legacy of the Titanic*. Stanford: Stanford University Press, 1995.

Chicago Fire

Bales, Richard F. *The Great Chicago Fire and the Myth of Mrs. O'Leary's Cow*. Jefferson, N.C.: McFarland & Company, 2002.

Kogna, Herman, and Robert Cromie. *The Great Fire: Chicago 1871*. New York: G.P. Putnam's Sons, 1971.

Changes Along the River: 19th Century

Association for the Improvement of the Chicago River. *Chicago! Where Railroad Traffic and Lake Transportation Meet: Snapshots from Proceedings of River Improvement Meeting, and Great Northern Hotel*. Conference Proceedings. Chicago: Ryan & Hart Printers, 1896.

Chicago & Alton Railroad Company. *A Guide to the Chicago Drainage Canal: With Geological and Historical Notes to Accompany the Tourist via the Chicago & Alton Railroad*. Chicago: Rand, McNally & Co Printers, 1895.

Clemensen, A. Berle. *Illinois and Michigan Canal, National Heritage Corridor, Illinois. Historical Inventory, History, and Significance*. Denver: National Park Service, 1985.

Hall, William Mosley. *Chicago River and Harbor Convention: An Account of Its Origin and Proceedings*. Edited by Robert Fergus. No. 18 of *Fergus Historical Series*. Chicago: Fergus Printing Company, 1882.

Lamb, John. "I&M Canal: A Corridor in Time." http://imcanal.lewisu.edu/index.htm

Longerwood Mfg. Co. *Contractor's Methods Employed on the Great Chicago Drainage Canal*. New York: Lidgerwood Mfg. Co., 1895.

Changes Along the River: 20th Century

Carder, Carol. "Chicago's Deep Tunnel." *Compressed Air Magazine*. October/November 1997, pp. 10–17.

Chicago Daily Tribune. "Open New Lock." September 8, 1938.

City of Chicago. Department of Planning and Development. *Chicago River Corridor Development Plan; Also Design Guidelines and Standards*. Chicago, 1999.

---. *An Ordinance to Provide for Altering the Channel of the South Branch of the Chicago River between West Polk Street and West Eighteenth Street and to Provide for Certain Property Adjustments in Connection Therewith*. Chicago, 1926.

Krohe Jr., James. "Flood of Memories." *Chicago Reader*. April 9, 1993.

Robertson, Joe. "Bills Still Trickling in a Year after Great Flood." *Southtown Economist*. April 11, 1993.

Sanitary District of Chicago. *Industrial Development Along the Chicago Sanitary and Ship Canal*. Chicago, 1906.

Schmid, Jon. "'Mystery' Barge Must Be Moved." *Chicago Sun-Times*. April 26, 1999.

Underwater Archaeological Society of Chicago. "Tym-Barge Text." www.chicagosite.org/uasc/tymtext.htm

Water Quality

City Club of Chicago. *Water Purification as a Public Health Problem in Chicago*. Chicago: City Club of Chicago, 1936.

Comptroller General of the United States. *Metropolitan Chicago's Combined Water Cleanup and Flood Control Program: Status and Problems*. Washington, D.C.: Government Accountability Office, 1978.

Environment and Energy Publishing, LLC. "Chicago Project Aims to Broaden Appeal of Wastewater Treatment Functions." *Land Letter*. April 2004.

Kink, Beth. "Notes from Our Underground: Touring the Deep Tunnel." *The Regional News*. January 9, 1997.

Metropolitan Water Reclamation District of Greater Chicago. *Stickney Water Reclamation Plant*.

---. *TARP: Little Calumet Leg Tunnel*.

---. *Tunnel and Reservoir Plan, Mainstream Pumping Station and Calumet Pumping Station*.

O'Connell, James C. *Chicago's Quest for Pure Water*. Washington, D.C.: Public Works Historical Society, 1976.

Ritter, Jim. "Stickney's Sweet Smell of Success." *Chicago Sun-Times*. October 24, 1993.

Sanitary District of Chicago. *Report on Industrial Wastes from the Stockyards and Packingtown in Chicago*. Vol. 2. Chicago, 1921.

Architecture

Pridmore, Jay. *A View from the River: The Chicago Architecture Foundation River Cruise*. San Francisco: Pomegranate, 2000.

Schulze, Franz, and Kevin Harrington. *Chicago's Famous Buildings*. 4th ed. Chicago: University of Chicago Press, 1993.

Environmentalism and Recreation

Biemer, John. "Five Dozen Scientists Call Invasive Species the Most Urgent Environmental Threat to the Great Lakes & Mississippi River Basin: Barriers Urged for Area Rivers." *Chicago Tribune*. May 15, 2003.

Chicago River Canoe & Kayak. "A Birder's Trip Description." www.chicagoriverpaddle.com/birds.html

Chicago River Paddling/Fishing. "Chicago Area Paddling and Fishing Guide." http://pages.ripco.net/~jwn/chicago.html.

Chrzastowski, Michael J. *The Chicago River Mouth: Geology of the Chicago Lakeshore*. Illinois State Geologic Survey Map, 1998.

Cohn, Naomi J. *Voices of the Watershed: A Guide to Urban Watershed Management Planning*. Chicago: Friends of the Chicago River and the Illinois EPA, 1999.

Freedman, Lew. "A Peaceful Canoe Trip Amid the City," *Chicago Tribune*. July 10, 2001.

Friends of the Chicago River. "About the Adopt a River Downtown." www.chicagoriver.org/programs/aardowntown.asp

---. "Downtown Fish Flock to New Hotel." www.chicagoriver.org/programs/aardowntown.asp

---. *The Unofficial Paddling Guide to the Chicago River: Highlighting the North Branch and the Frese Trail*. Chicago: Friends of the Chicago River, 1996.

Frisbie, Paul. *The Chicago River from Your Window: An Illustrated River Watcher's Guide*. Chicago: Friends of the Chicago River, 2002.

Illinois Environmental Protection Agency. "Chicago Area Waterway System Use Attainability Analysis Fact Sheet." http://www.chicagoareawaterways.org/indexphp/facts/2.html

Openlands Project, Illinois Paddling Council, and Northeastern Illinois Planning Commission. "Northeastern Illinois Regional Watertrails." Map and brochure. 2002.

Quinn, Pat, and Laurene von Klan. "Historic Summit Can Help Make Chicago River 'Swimmable and Fishable' by 2020." Office of the Lieutenant Governor of Illinois. Press release. Springfield, September 18, 2003.

The River Reporter: A Newsletter for Friends of the Chicago River. "The River Shows It Mussels." Fall 2002.

US Fed News. "Mayor Daley Releases Chicago River Agenda." July 30, 2005.

About the Author

Jonathan Genzen, a physician by training, is an avid canoeist. He has also served on the Board of Directors of the Chicago River Rowing and Paddling Center. Jonathan has spent countless hours paddling on the Main and South Branches of the Chicago River when he lived in Hyde Park, working toward his Ph.D. in neurobiology and M.D. from the University of Chicago. He previously lived in Evanston, Illinois, when he was a student at Northwestern University. Jonathan's unique perspective on the Chicago River inspired a profound desire to give something back to the city of Chicago, resulting in this, his first book. He is currently studying laboratory medicine at Yale University.

Websites

For more information on this project, visit: *www.chicagoriver.net*

Libraries

Chicago Public Library *www.chipublib.org*
Lewis University Canal and Regional History Special Collection *http://imcanal.lewisu.edu*
Library of Congress: American Memory *http://memory.loc.gov*
Newberry Library *www.newberry.org*

Museums

Chicago History Museum *www.chicagohistory.org*
McCormick Tribune Bridgehouse & Chicago River Museum *www.bridgehousemuseum.com*

Organizations

Canal Corridor Association *www.canalcor.org*
Chicago Architecture Foundation *www.architecture.org*
Chicago Maritime Society *www.chicagomaritimesociety.org*
Chicago Maritime Festival *www.chicagomaritimefestival.org*
Eastland Disaster Historical Society *www.eastlanddisaster.org*
Eastland Memorial Society *www.eastlandmemorial.org*
Friends of the Chicago River *www.chicagoriver.org*

Recreation

Chicago Area Paddling/Fishing Guide *www.chicagopaddling.com*
Chicago Area Sea Kayakers Association *www.caska.org*
Chicago Kayak *www.chicagokayak.com*
Chicago River Canoe and Kayak *www.chicagoriverpaddle.com*
Chicago Rowing Center *www.rowchicago.org*
Chicago Rowing Foundation *www.rowchicago.com*
Chicago River Rowing and Paddling Center *www.chicagorowing.org*
Chicagoland Canoe Base *www.chicagolandcanoebase.com*
Chicago Park District *www.chicagoparkdistrict.com*
Lincoln Park Boat Club *www.lpbc.net*

River Cruises

Chicago's First Lady Architectural Cruises *www.cruisechicago.com*
Chicago Line Cruises *www.chicagoline.com*
Wendella Sightseeing Boats *www.wendellaboats.com*

Acknowledgments

I am honored to have had the privilege of including so many photographs from the Chicago History Museum (CHM; formerly the Chicago Historical Society). Throughout this project, the CHM Research Center provided valuable assistance in exploring their truly remarkable collection. Special gratitude is extended to Bryan McDaniel for coordinating image permission and reproduction. This book would not have been possible without their cooperation.

Many individuals also provided helpful advice throughout the course of this project. Particular appreciation is extended to David M. Solzman, photographer and author of *The Chicago River: An Illustrated History and Guide to the River and Its Waterways.* His dedication to the Chicago River is without comparison, and our common interest in the river's history has inspired many fascinating conversations. Libby Hill, author of *The Chicago River: A Natural and Unnatural History,* graciously provided me with a helpful set of comments during preparation of the manuscript. Her knowledge of the Chicago River is astounding, and is matched only by her ability to describe the river so eloquently. Additional gratitude is extended to the many other individuals who provided helpful comments on the manuscript, especially Mary Carroll and Richard Lanyon of the Metropolitan Water Reclamation District of Greater Chicago (MWRD), Margaret Frisbie of Friends of the Chicago River, Susan Urbas and William Pomerantz of the Chicago River Rowing and Paddling Center, Gary and Holly Genzen, David Genzen, Lindy Barrett, and Jennifer Gosselin.

This book, so fundamentally dependent on access to historical images, relied heavily on the generosity and cooperation of many other individuals and institutions. I'd like to thank John C. Farnan at MWRD, Cristin J. Waterbury at the Wisconsin Maritime Museum, Kathleen Zar at the University of Chicago Library, the Alfred Whital Stern Collection of Lincolniana at the Library of Congress, the Robert Dennis Collection of Stereoscopic Views at the New York Public Library, Paul J. Schueler and Kevin O'Brien at the Tippecanoe County Historical Association, John Lamb at the Lewis University Library/Canal and Regional History Special Collection, Jim Jarecki at the Underwater Archaeological Society of Chicago, Phil O'Keefe for details regarding the Chicago River tunnels, bookseller Robert S. Brooks for helping me acquire an original copy of A.T. Andreas' landmark *History of Early Chicago,* David M. Solzman for scanning MWRD negatives, and the family of Michael Tym for access to photographs of their father's amazing maritime invention.

Numerous professional and amateur photographers graciously provided modern color photographs for the book, including Chris Anderson, Marilyn Audsley, Pete Baker, Tony Dornacher, Tamsin Edwards, Kathryn Fitzgerald, Bradley M. Froehle, Michael Jones, Brian McCoy, Michael Meiser, Paul W. Puckett, David Solzman, Sherwin Techico, Bonnie Underwood, Wei-Peng Yong, Peter James Zielinski, and Kevin Zolkiewicz. Particular gratitude is extended to Denise Foy for taking photographs specifically for this project. We are fortunate in having the opportunity to view the modern Chicago River through the eyes of this diverse group of fantastic visual artists.

This endeavor would not have been possible without the faith and dedication of John Fielder, Jenna Browning, Linda Doyle, Jennifer Jahner, and Craig Keyzer of Westcliffe Publishers. I will forever be grateful for your trust and understanding throughout this wonderful journey.

My friends at Yale, including Drs. Christopher Tormey, Abraham Tzou, Richard Torres, Stephanie Colegio-Eisenbarth, Yuri Fedoriw, Tori Eid, Jonathan Bennett, and Michelle Erickson have all been amazingly supportive during the completion of the project at such an amazing point in my life—medical residency! I'd also like to thank Thaddeus and Katie Brink, Robert and Paula Hurley, Mary Roland, Chester Drum, Dawn Tefft, Caitlin and Leo Trasande, Daniel McGehee, and Jennifer Gosselin. They have not just inspired me, but also provided valuable encouragement when I needed it most. Finally, I would like to thank my father for setting such a fine example of authorship, and my mother for helping me to explore the world and find my topic.